stripes, grids
and checks

stripes, grids and checks

Michael Hann

Bloomsbury Academic
An imprint of Bloomsbury Publishing Plc

BLOOMSBURY
LONDON · NEW DELHI · NEW YORK · SYDNEY

Bloomsbury Academic

An imprint of Bloomsbury Publishing Plc

50 Bedford Square	1385 Broadway
London	New York
WC1B 3DP	NY 10018
UK	USA

www.bloomsbury.com

BLOOMSBURY and the Diana logo are trademarks of Bloomsbury Publishing Plc

First published 2015

British Library Cataloguing-in-Publication Data
A catalogue record for this book is available from the British Library.

ISBN:	HB:	978-0-8578-5626-5
	PB:	978-0-8578-5657-9
	ePDF:	978-0-8578-5528-2
	ePub:	978-0-8578-5777-4

Library of Congress Cataloging-in-Publication Data
Hann, M. A.
Stripes, grids and checks / Michael Hann.
pages cm
Includes bibliographical references and index.
ISBN 978-0-85785-626-5 (hardback) – ISBN 978-0-85785-657-9 (paperback)
1. Decoration and ornament–Themes, motives. 2. Stripes. 3. Grids (Crisscross patterns) I. Title.
NK1570.H355 2015
701'.15–dc23
2015005168

Typeset by Integra Software Services Pvt. Ltd.
Printed and bound in India

To Nell and Peter Hann

contents

list of illustrations xi

preface xv

acknowledgements xvii

1 introduction 1

2 fundamentals (lines and stripes) 7

 introduction 7

 lines 7

 stripes and their classification 8

 summary 15

3 enclosed figures and forms 41

 introduction 41

 circles, squares and triangles 42

 regular polygons 45

 spatial organization 45

 polyhedra and spheres 48

 summary 50

4 a question of proportion 53

introduction 53

arithmetical or geometrical 54

evidence for past use 55

the golden section 57

dynamic symmetry 58

the Modulor 60

the Brunés Star 60

the plastic number 62

summary 63

5 grids – guidelines, frameworks and measuring devices 65

introduction 65

definitions and types 65

range of applications 66

grids from rectangles 68

summary 71

6 checks and tartans 73

introduction 73

definition and classification 73

varieties 75

Scottish clan tartans 78

summary 81

7 planned divisions of space **107**

introduction 107

regular and semi-regular divisions 107

demi-regular divisions 107

non-edge-to-edge divisions 107

aperiodic divisions 109

summary 113

8 three-dimensional lattices and other constructions **115**

introduction 115

cubic and rectangular three-dimensional
lattice constructions 117

domes 117

space frames 119

summary 120

9 steps towards analysis **121**

introduction 121

past working methods 121

the potential of symmetry analysis 122

case studies 123

summary 123

10 transformation of compositional frameworks **127**

introduction 127

manipulation and transformation 127

transformations of semi-regular, demi-regular
and aperiodic grids 127
summary 130

11 in conclusion 131

references 133

index 139

list of illustrations

acknowledgements

Unless stated otherwise, all photographic work is by the author. Graphic and scanning work associated with geometric and other images is by Chaoran Wang (CW), Alice Humphrey (AH) and Jeong Seon Sang (JSS), under the direction of the author.

plates

All plates are taken from samples presented in Stewart (1893) and cross-referenced with samples held at ULITA – An Archive of International Textiles, University of Leeds (UK).

1a Balmoral tartan.

1b Brodie tartan.

1c Campbell of Breadalbane tartan.

1d Davidson tartan.

2a Drummond of Perth tartan.

2b Drummond of Strathallan tartan.

2c Fraser of Lovat tartan.

2d From a coat worn at the Battle of Culloden.

3a From a cloth fragment found at Culloden battlefield.

3b From cloth worn by Prince Charles Edward at Holyrood Palace.

3c From Prince Charles Edward's cloak (at Fingask).

3d Huntley tartan.

4a Kennedy tartan.

4b Logan tartan.

4c Lord of the Isles (hunting) tartan.

4d MacCallum tartan.

5a MacDonald tartan.

5b MacIntyre and Glenorchy tartan.

5c MacKeane (or MacIan) tartan.

5d MacLachlan tartan.

6a MacLeod tartan.

6b MacNeill tartan.

6c MacPherson tartan.

6d MacRae tartan.

7a Montgomerie tartan.

7b Ogilvie tartan.

7c Ogilvie (hunting) tartan.

7d Prince's Own tartan.

8a Stewart of Appin tartan.

8b Stewart of Galloway tartan.

8c Robertson tartan.

8d Stewart tartan.

figures

1.1–1.18 Stripes. 3–4

1.19–1.27 Checks. 5

2.1 Detail of an architectural plan indicating scale of drawing. 8

2.2–2.17 Examples of textile stripes, produced in Britain in the late nineteenth or early twentieth centuries. 10

2.18–2.29 Details of hand-cut *katagami* (stencils used in the production of a variety of traditional Japanese resist-dyed textiles). 12

2.30–2.32 Original designs developed by reference to the *katagami* collection held at ULITA – An Archive of International Textiles, University of Leeds (UK). 13

2.33 Knitted leg coverings. Annual fashion show, Leeds College of Art and Design, May 2008, Royal Armouries, Leeds (UK). 14

2.34–2.129 Stripe designs, 2014. 16–39

3.1 Reflection symmetry (together with rotation created through intersecting reflection axes) (JSS). 42

3.2 Rotational symmetry (twofold to sixfold rotation) (JSS and CW). 42

3.3 Vesica piscis (CW). 43

3.4 Sacred-cut square (CW). 44

3.5 A 3 × 3 magic square (CW). 44

3.6 The 4 × 4 magic square of Dürer (CW). 44

3.7 Hermann grid (CW). 44

3.8 Necker cube (CW). 46

3.9 The 5, 4, 3 Egyptian triangle (CW). 46

3.10 The thirty-six-degrees isosceles triangle (CW). 46

3.11 Combination of ten thirty-six-degrees isosceles triangles in circular format (CW). 46

3.12 Impossible triangle (CW). 47

3.13 A further impossible triangle (CW). 47

3.14 Impossible square (CW). 47

3.15 Impossible pentagon (CW). 47

3.16 Impossible hexagon (CW). 47

3.17 Impossible octagon (CW). 47

3.18 Schematic illustration of radial organization (CW). 49

3.19 Schematic illustration of clustered organization (CW). 49

3.20 Schematic illustration of linear (and parallel) organization (CW). 49

3.21 Schematic illustration of centralized organization (CW). 49

3.22 Schematic illustration of a grid form of organization (CW). 49

3.23 The five Platonic (or regular) polyhedra (tetrahedron, octahedron, cube, icosahedron and dodecahedron) (JSS). 50

3.24 Tetrahedron (JSS). 51

3.25 Tetrahedron net (JSS). 51

3.26 Octahedron (JSS). 51

3.27 Octahedron net (JSS). 51

3.28 Cube (JSS). 51

3.29 Cube net (JSS). 51

3.30 Icosahedron (JSS). 52

3.31 Icosahedron net (JSS). 52

3.32 Dodecahedron (JSS). 52

3.33 Dodecahedron net (JSS). 52

3.34 The truncated icosahedron (JSS). 52

4.1 Commensurable ratios (JSS). 54

4.2 Golden-section construction (AH). 57

4.3 Golden-section rectangle (AH). 58

4.4 Golden-section spiral (AH). 58

4.5 Successive root rectangles (JSS). 59

4.6 Rectangle of the whirling squares (CW). 59

4.7 Brunés Star outline (JSS). 61

4.8 Brunés Star divisions (JSS). 61

4.9 Brunés Star with full diagonals (CW). 61

5.1 Simple three-by-three grid on a square composition. 65

5.2–5.11 Mondrian-type images. 69

5.12 Compositional grid with plastic-number unit cells (AH). 70

5.13 Compositional grid with golden-section unit cells (AH). 70

5.14 Compositional grid with root-4 (2:1) unit cells (AH). 70

6.1–6.12 Selection of check-type designs, late nineteenth or early twentieth centuries. 74

6.13–6.21 Details from a selection of *kata-gami*, early twentieth century. 77

6.22–6.117 Check designs, 2014. 82–105

7.1–7.3 Regular divisions (JSS). 108

7.4–7.11 Semi-regular divisions (JSS). 109

7.12–7.31 Demi-regular divisions (AH). 110–112

7.32–7.34 Non-edge-to-edge divisions (JSS). 112

7.35 Aperiodic division (JSS). 113

7.36–7.41 Selection of regular and semi-regular compositional grids with moiré (interference) effects (AH). 114

8.1–8.5 The five Bravais lattices (CW). 116

8.6 A cubic lattice (AH). 117

8.7 A golden-section-rectangle three-dimensional lattice (AH). 118

8.8 A 1:1.414 three-dimensional lattice (AH). 118

8.9 A 1:1.732 three-dimensional lattice (AH). 118

8.10 A 1:2 three-dimensional lattice (AH). 118

8.11 A 1:2.236 three-dimensional lattice (AH). 118

8.12 A 1:1.3247 three-dimensional lattice (CW). 118

9.1 Symmetry template (CW). 122

9.2 (a) Dome of the Rock (Jerusalem) (CW). (b) Plan of Gyantse Kumbum, Tibet (CW). (c) Bramante design for St Peter's (Vatican City) (CW). (d) Plan of Shwezigon Paya, Myanmar (CW). (e) Plan of Pha That Luang, Lao (CW). (f) Plan of Boudhanath Maha-chaitya, Kathmandu (CW). 124

10.1–10.3 Transformations of semi-regular grids (CW). 128

10.4–10.12 Transformations of demi-regular grids (CW). 129

10.13 Transformation of an aperiodic grid (CW). 130

11.1–11.2 Transformed compositional grids (AH). 132

preface

Various analysts have maintained that certain structural components or geometric procedures underpin all that appears 'complete', 'resolved' or 'finished' in the visual arts and design. In other words, it has been argued that visual completeness results when visual artists, designers and builders follow rules, guidelines or canons of proportion or composition, and there has been a vast amount of literature which claims to have discovered such rules, guidelines or canons of composition.

What is indeed apparent is that certain aesthetic features, related closely to composition, conform to, or fit within, various underlying frameworks which may have acted as proportion markers. These frameworks may have been drawn up and used consciously, or compositional decisions may have been made unconsciously but by reference to some form of imaginary framework (typical in modern page layout where often a simple grid of two vertical lines and two horizontal lines is imagined to split the page into nine rectangles, with each of these rectangles acting as 'markers' for the placing of blocks of text or illustrative material). On the face of it, this book is concerned with stripes, grids and checks, and the outward manifestation of these in the visual arts and design. A further underlying purpose is to identify how grids, in particular, can act as structural or aesthetic markers or determinants and how, in this role, they may be of value to the visual-arts-and-design practitioner. The intention is not to argue for, or present, a series of procedures which will act as a basis for a practitioner's framework applicable to all visual-arts-and-design projects no matter what their context. Instead, the emphasis is on identifying the wide range of perspectives and guidelines which may have inspired decision-making among past visual artists and designers, and, taking account of these considerations, the aim is to propose fresh insights which may be of value in modern times to both practitioners and analysts.

MAH, Leeds 2015

acknowledgements

The author is indebted to Ian Moxon for his constructive review of the manuscript, his useful commentary and helpful editorial advice. Thanks are due also to Chaoran Wang, Jeong Seon Sang, Alice Humphrey and Victoria Moore, for their efforts in assisting with the preparation and production of illustrative material. Gratitude is extended also to David Holdcroft, Christopher Hammond, Jeremy Hackney, Dirk Huylebrouck, Josh Caudwell, Irfan Mohammad, Jonathan Rosenthall, Peter Byrne, William Davidson (Carncastle Properties), Michela Rossi, Eric Broug, Marjan Vazirian, Margaret Atack, Jill Winder, Patrick Gaffikin, Briony Thomas, Edward Spiers, Margaret Chalmers, Hong Zhong, Carol Bier, Jae Ok Park, Kevin Laycock, Young In Kim, Myung-Sook Han, Sookja Lim, Catherine Docherty, Roger X. Lin, Cigdem Cini, Damian O'Neill, Patrick McGowan, Biranul Anas, Behnam Pourdeyhimi, Myung-Ja Park, Kyu-Hye Lee, Chil Soon Kim, Jin Goo Kim, Kate Wells, Jean Mitchell, Peter Speakman, Kenneth Jackson, Sangmoo Shin, Grace Eun Hye Kim, Patricia Williams, Sandra Heffernan, Barbara Setsu Pickett, Kahfiati Kahdar, Eamonn Hann, Teresa Hann, Mairéad O'Neill, Barney O'Neill, Jim Large, Moira Large, John MacMahon, John MacNamara, Leyla Yildirim, Kieran Hann, Roisin Mason, Tony Mason, Martin O'Kane, Peter Howarth, Rory McTurk, Donald Crowe, Dorothy Washburn, Doris Schattschneider, Jay Kappraff, Alina Abdullah, Eugene Nykolyszyn, Brian Wilton, Michael Dobb, Keum Hee Lee, Clare Lamkin, Helen Farrar, Shaun Clarke, Haesook Kwon, Anothai Cholachatpinyo, Mark Boyne, Michael Baun, Dave Fenwick, Erik Schelander and Young In Kim. Acknowledgement is extended also to the following students: Obafunbi Adebekun, Rosanna Adkins, Yasmeen Alfaify, Charlotte Allen, Olivia Bambrough, Katya Barton-Chapple, Naomi Baxter, Jessica Bennett, Kate Binns, Zoe Blair, Harriet Bourne, Mary Bowkett, Hannah Brook, Magdalena Brzegowy, Emma Buckee, Maha Bughenaim, Lisa Byers, Natalie Cahill, Scott Cameron, Lucy Charnley, Emily Clarke, Alice Collins, Charlotte Collins, Jasmine Collins, Sarah Conn, Emily Conroy, Frances Cooper, Bronagh Courtney, Clare Darby, Freya Dick-Cleland, Amber Druce, Chloe Dunn, Alice Facey, Aimee Fawcett, Hazel Fletcher, Isabel Fletcher, Krystal Fox, Oliver Fox, Elizabeth Gatenby, Danice Gilmore, Stephanie Graham, Hannah Greenhalgh, Khimi Grewal, Sophie Harper, Rose Harrington, Bryony Hatrick, Somaya Hayat, Imogen Henderson, Naomi Henderson, Leanne Hewitt, Katrina Holmes, Yvonne Hsu, Victoria Hughes, James Inchbald, Fatima Islam, Charlotte Jackson, Paula Jankowska, Bronte Jeffrey-Mann,

Sophie Johnson, Sian Jones, Tayla Keir, Pamela Lee, Deniche Benevides Leoncio I, Gemma Li, Xiaofan Liu, Emilia Livingston, Claudia Lloyd, Sarah Longworth, Bethany Mackman, Natalie Mallalieu, Ellen McLoughlin, Sean Mills, Elizabeth Minnis, Defaf Moalla, Harriet Muddiman, Nehal Nasir, Kayleigh Naysmith, William Nichols, Thabata Oliveira, Jacob Parnell-Hogg, Megan Peirson-Shaw, Cassandra Place, Matthew Proctor, Sophie Proops, Selma Quek, Katie Reynolds, Carys Ridsdale, Tara Rowse, Sebastian Scott, Amy Sculley, Hollie Sharp, Naomi Sterling, Rachael Stirling, Charles Straw, Rachel Stutins, Muxiao Sun, Katarzyna Szewczyk, Maria Trujillo Olaiz, Megan Tullis, Emily Tyson, Aleksandar Velikov, Samantha Walsh, Yuwei Wang, Fergus Wassell, Catherine Wattrus, Emma Webb, Tessa Whistler, Jasmine Williams, Erika Wilson, Rachel Young, Bingmi Zhou and Pawel Znojek.

Last, and by no means least, gratitude and thanks are extended to Naeema, Ellen-Ayesha and Haleema-Clare Hann. Every effort has been made to extend acknowledgement where it is due, and the author apologizes in advance, should such acknowledgement have been omitted. Unless otherwise specified, photographic images were produced by the author. The author accepts responsibility for all omissions, inaccuracies and incorrect statements.

1

introduction

This book is concerned with the ordered or planned division of space. The aim is to identify and consolidate various principles of value to both analysis and composition. The intended audience is students or recent graduates of design, though there is much of value also for students and practitioners in other visual disciplines including the areas often referred to as the fine arts. The expression 'visual arts and design' will be used in this book to cover painting, other forms of image-making and sculpture, and will include also the most popular design disciplines (i.e. industrial, graphic, interior and architectural design, as well as product, ceramic, textile, fashion, landscape and website design). The fine arts (some would say) serve a particular *raison d'être* and, at least partly, make comment on the world around us, society and its structure, conflict, war and peace and, amongst much else, the full range of factors and emotions influencing the human condition. Design, on the other hand, must, by modern necessity, take into account various economic, social, environmental, psychological and technological factors as well as the broad range of conditions influencing human use or application of the designed object. There are however various structural components and procedures common to all these

visual-arts-and-design disciplines, and it is the identification of these which is the principal focus of this book.

In the development of designs or other visual statements, it is often necessary for the practitioner to engage in a process of organization or composition, involving the arrangement of constituent visual elements. Decisions relating to the organization of component parts make reference often to an underlying structural framework. This underlying framework may come in several forms, including two- or three-dimensional guidelines, referred to often as grids or lattices, and consisting invariably of familiar polygons and other geometric constructions (Hann, 2012: 44–46).

Consideration is given to the nature of lines and how they may be assembled to create grids, believed, at least in the popular mind, to be those structures which consist of two systems of parallel lines, one superimposed, often at ninety degrees, on the other, creating equally sized rectangular or square cells (often referred to as 'unit cells'). As will be shown here, further varieties of grid are possible. From the viewpoint of the visual artist and designer, grids are best considered as frameworks which provide structural guidelines, occasionally in association with one or more geometric operations, to

enable the creation of designs or compositions of various types which, when complete, lie on top of the underlying grids. Grids are thus the structures which underpin many successful designs or other visual compositions; grids are hidden generally from view in the finished object or construction, but are none the less crucial to visual identity or practical success. On some occasions visual impressions of a grid structure may remain in a finished composition, design or construction, as with the façades of typical twentieth- and early twenty-first-century high-rise architecture.

When represented, for example, on paper, grids bear a similarity to tiling-design arrangements. A tile is simply a single two-dimensional shape, often in the form of a straight-sided polygon, whereas a tiling is a collection of such shapes which cover (or tessellate) the plane without gap or overlap. Categories of grid are proposed in this book, based on three periodic-tiling classes (known as 'regular', 'semi-regular' and 'demi-regular' tilings). One particular type of tiling which does not show strict repetition, and is known as an aperiodic tiling, is introduced also, and the relevant format proposed as a compositional grid.

Consideration is given at an early stage to stripes and, at a later stage in the book, to how these are assembled to produce checks. Checks are best considered as a (visible) sub-set of grids and consist of two assemblies of parallel lines (or stripes), one superimposed on the other at ninety degrees. Both stripes and checks remain visually apparent in the finished composition. The most common and widely known check comes in woven-textile form, often with a systematic arrangement of coloured threads in both lengthways (or warp-ways) and widthways (or weft-ways) directions. Scottish clan tartans famously display this feature.

Selections of images produced by visual-arts-and-design students at the University of Leeds, in response to a request to create collections of stripes and checks, are presented in Figures 1.1–1.18 and 1.19–1.27 respectively. What is apparent, both from these illustrations and from the publications dealing with such visual phenomena, is that stripes are perceived conventionally as assemblies of parallel linear components, and checks as combinations of two sets of such components overlapping at ninety degrees to create constituent rectangular shapes. These simple compositional formats have been adopted and applied for centuries, particularly in textile manufacture (the area associated commonly with stripes and checks). In the early twenty-first century, however, with various forms of digitally assisted composition in widespread use, visual artists and designers have been able to step outside the compositional norms of the past. While this escape is not easily possible in the context of weaving, it is apparent that digital forms of printing, on paper, plastics, textiles and other surfaces, have permitted apparently limitless design flexibility, and have encouraged visual artists and designers to think creatively outside the conventional formats identified above.

The objective of this book is thus to consider the nature of various structural components, sometimes hidden and at other times visually apparent, including lines and assemblies of

Figures 1.1–1.18 Stripes. Courtesy of: Katya Barton-Chapple, Mary Bowkett, Bethany Mackman, Hannah Brook, Bingmi Zhou, Yuwei Wang, Catherine Wattrus, Claudia Lloyd, Harriet Muddiman, Emilia Livingston, Kate Binns, Emma Webb, Charles Straw, Rachel Stutins, William Nichols and Xiaofan Liu.

Figures 1.1–1.18 (*continued*)

Figures 1.19–1.27 Checks. Courtesy of: Bethany Mackman, James Inchbold, Chloe Dunn, Victoria Hughes, Katie Reynolds, Carys Ridsdale, Claudia Lloyd and Catherine Wattrus.

lines, stripes, grids and lattices, as well as related phenomena such as checks. The intention is to inspire visual-arts-and-design practitioners by introducing and illustrating various conventional and unconventional forms of these visual phenomena, as well as to propose a range of compositional frameworks and a simple procedure to assist with visual analysis.

2

fundamentals (lines and stripes)

introduction

The purpose of this chapter is to discuss the nature of lines, considered conventionally as the shortest path connecting two points. Sometimes visible and sometimes imaginary, lines play a fundamental role as structural or visual components of the majority of phenomena dealt with in this book. Attention is given also to stripes, phenomena with dimensions defined or bordered by lines, and best considered as series of parallel blocks, each of greater length than width.

lines

A line has a beginning and an end, and has length but no width (Hann, 2012: 12). Lines may occur singly, or may be arranged in groups, and may be parallel or non-parallel, continuous or punctuated, straight, curved, wavy or zigzagged, intersecting or clearly separated, arranged randomly or systematically. A line divides space and, in the two-dimensional context, can act as a boundary or border between adjacent, sometimes contrasting, areas. Lines are evident in nature, at the nano, micro and macro levels, and in the constructed and manufactured environments. They can be oriented in

particular directions, and can combine, meeting at angles to create enclosed two-dimensional figures known as polygons, or curve continuously to create oval, spiral or circular shapes. Typically represented using ink or pencil graphite on white paper, lines may be readily apparent visually in the early stages of creative development and, after serving as guides to the placing of visual elements, may be hidden from view in the finished composition, design or construction or, alternatively, may remain apparent and play a dominant visual role. Lines act as markers to aid judgements relating to proportion, an important consideration in the context of this book.

Visual artists and designers may use lines in the creation of a sketch, drawing or plan of a composition, design, object or construction. Lines may indicate the shape and relative angles or position of component parts of a design. The length of lines in a scale drawing is an indication of the desired dimensions of the designed object or construction. A detail of an architectural plan, including a scale to assist builders, is given in Figure 2.1.

The word 'line' is used frequently in everyday phrases to express a path from one point in space to another, a boundary between two states or a direction, continuum or orientation. Examples of the use of the word 'line' include

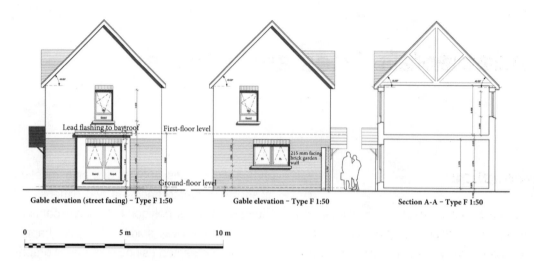

Gable elevation (street facing) – Type F 1:50 Gable elevation – Type F 1:50 Section A-A – Type F 1:50

0 5 m 10 m

Figure 2.1 Detail of an architectural plan indicating scale of drawing. Courtesy of William Davidson (Carncastle Properties).

railway line, borderline, skyline, tramline, eye-line, telephone line, line of argument, down the line, red line, treeline, mainline, front line, cross the line, fine line, on line, chorus line, fault line, fishing line, line manager, line-up, hair line, Maginot line, Siegfried line, dotted line, bottom line, touch line, branch line, bloodline, shipping line, guideline and outline. Readers can probably think of others to expand the list.

Lines can define limits. An outline defines the outer spatial boundaries or limits of a figure or object. This is relatively straightforward in the context of a two-dimensional figure, drawn on a sheet of paper; in this case, there is only one possible outline. With an object in three dimensions, various outlines may be considered, the dimensions of each depending on the viewing position of the observer; different observers positioned at different spatial points will observe different outlines. Asymmetrical objects have a greater number of potential outlines than highly symmetrical objects such as spheres (which

have only one outline when viewed at a given distance) and domes, cones and cylinders, each of which, when placed upright, has only one outline when viewed horizontally from a given distance. Further discussion of the nature of line was given previously by the present author (Hann, 2012: 11–14).

stripes and their classification

Stripes differ from lines and have a clearly recognizable and measurable width. They occur occasionally in single use (as in some flags or armorial crests) but are more common as series of parallel bars, each of greater length than breadth. Commonly, stripes exhibit a strict regularity (a typical characteristic of mass-produced striped textiles, for example), though they may on occasion show variation in width and directional orientation; zebra and tiger stripes are examples from nature. Stripes are found in all

forms of design and are associated popularly with textiles. Textile stripes may be of various widths, and may be used often to fulfil a decorative function (though in various cultures they may encapsulate an added symbolic or culturally specific meaning).

Stripes, in bright primary or secondary colours, at fairgrounds, circuses and seaside resorts, suggest joviality. They can act as directional devices, encouraging the eyes of the observer to search or follow in a given direction. They can add an air of formality to the interior of a dwelling (e.g. Regency striped upholstery or wall coverings) or as clothing (e.g. a pin-striped business suit).They can offer support visually when placed either horizontally or vertically. Stripes can act also as a basis for certain forms of visual illusion and optical effect; the artist Bridget Riley famously used stripes in her paintings to challenge the visual perception of viewers.

Hampshire and Stephenson (2006b) considered stripes under a wide range of headings. Classic stripes were considered to be those that 'touch our everyday lives' (Hampshire and Stephenson, 2006b: 6), especially stripes used in clothing (and clothing accessories) as well as in various household settings and household objects. Illustrative examples given by Hampshire and Stephenson included pinstripes (mainly men's suiting fabrics), shirting stripes, Breton stripes (associated with French fishermen and nineteenth- and twentieth-century French onion sellers, who sailed to Britain from the coast of Brittany), various relatively modern striped T-shirts, and Cornish kitchenware (typically a blue-on-white striped pattern on mugs, cups, saucers, milk jugs, sugar bowls, etc.) manufactured initially in the 1930s by T.G. Green in the UK (Hampshire and Stephenson, 2006b: 16–27). Another important application identified by Hampshire and Stephenson was a cotton fabric known as 'ticking', used traditionally to upholster mattresses and pillows, and typically a relatively heavy, canvas-type construction in white or ecru with a contrasting single-colour stripe (2006b: 34).

Stripes have held long-term popularity in interior design, and the term 'Regency' has been used to refer to those stripes which, according to Hampshire and Stephenson, were originally called 'tiger' or 'Bengal' stripes and were associated with the British Raj in South Asia during the nineteenth and early twentieth centuries (2006b: 35). Stripes in woven textiles are created from at least one thread, invariably of a different colour from other parallel threads. In an uncut woven textile, stripes may orientate in a warp-ways direction (down the length of the textile) or, occasionally, in a weft-ways direction (across the width of the textile). Illustrations of printed or woven textile stripes, produced in Britain in the late nineteenth or early twentieth centuries, are given in Figures 2.2–2.17.

Often stripes have been used to indicate membership of a gathering or group, and may suggest a particular status or other identity. Stripes have been employed in some coats of arms, national flags, school or college uniforms (e.g. ties, blazers and scarves) and sports teams' outfits (both supporters and participants), and as indicators of military rank or regimental membership, or as ribbons attached to military medals.

Stripes can assist in the communication of particular themes or moods (Hampshire and

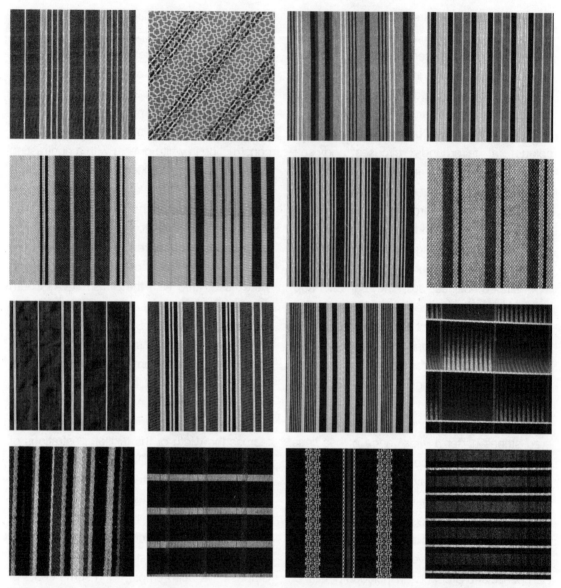

Figures 2.2–2.17 Examples of textile stripes, produced in Britain in the late nineteenth or early twentieth centuries. Courtesy of ULITA – An Archive of International Textiles, University of Leeds (UK).

Stephenson, 2006b: 74–119), and have been used in the design of numerous consumer products as well as in their advertising and promotion. They have been used to convey a signal, to attract attention (and denote a warning, for example), as camouflage, in optical effects, as bar codes, in typography and as contour lines on maps. Numerous examples are evident in the sphere of architecture, particularly in late twentieth and early twenty-first-century

high-rise buildings. O'Keeffe (2013), in her profusely illustrated *Stripes: Design between the Lines*, presented a stunning visual record of the use or presence of stripes in the natural and built environments, and in interior, fashion, textile and other surface-pattern design. Yoshimoto (1993: 8–11) provided an illustrative chart of traditional Japanese striped textiles, with a descriptive title for each example. A series of illustrations of hand-cut *katagami* (paper stencils used in the dyeing of a variety of traditional Japanese textiles), each incorporating a stripe-type effect, is presented in Figures 2.18–2.29. Three original designs inspired by the *katagami* collection held at the University of Leeds are presented in Figures 2.30–2.32.

Among most observers, it appears that stripes are considered as a simple entity with little real variation and thus not in need of any degree of classification. Because of this, no clear means of differentiation and classification appears to have been published, other than largely descriptive references found in textile-related publications. The simple means of classification suggested here draws on these textile-related sources.

When considered in the textiles context, the term 'stripe' is used to refer to 'the effect produced in a fabric by several bands or lines (usually, but not necessarily, of different colours) running in the direction of warp or from end to end of a piece of cloth' (ICS, 1906, part 3: 1). The wide degree of design differentiation possible is also highlighted:

the number of patterns that can be made, even if only two colours are used, is without

limit, since the width of the stripe may be varied from the width of a single thread to stripes several inches in breadth if it is desired, and again, broad and narrow stripes may be grouped in various ways, each new arrangement of the warp yarns forming a new pattern. (ICS, 1906, part 3: 2)

Despite the focus in general textile publications on woven and occasionally printed stripes, the design type is common also in knitted textiles, particularly for fashion end uses (e.g. Figure 2.33).

Because of the wide scope and range of types, it is difficult to group the different effects under appropriate headings. Often a rudimentary differentiation is made between 'regular' stripes and 'irregular' stripes. Regular stripes have been considered to be 'those patterns in which the bands of color, without regards to the number of colors used, are of equal width' (ICS, 1906, part 3: 2). Meanwhile, irregular stripes have been regarded as those which exhibit various widths. In each case, a definite repetition is expressed with a particular stripe sequence repeating itself across the width of the fabric. In the context of this present book, however, the definitions mentioned above are adjusted to allow the term 'regular stripe' to be used in all cases where a consistent degree of repetition (typical of mechanized textile manufacture) is evident (e.g. where a particular sequence of stripes, maybe of differing widths and colours, repeats itself). The term 'irregular stripe' is adopted to refer to stripe-type effects found commonly in nature, where each component may be of a different width and may have slightly different orientation (as with a tiger's stripes or

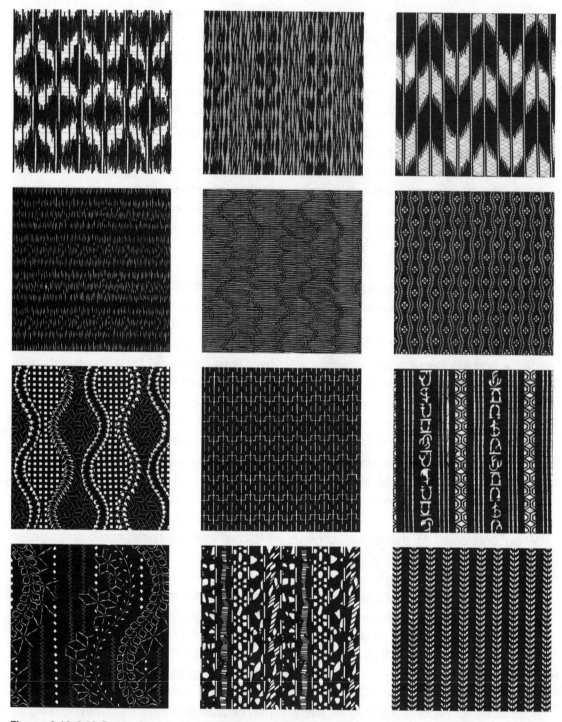

Figures 2.18–2.29 Details of hand-cut *katagami* (stencils used in the production of a variety of traditional Japanese resist-dyed textiles). Courtesy of ULITA – An Archive of International Textiles, University of Leeds (UK).

Figures 2.30–2.32 Original designs developed by reference to the *katagami* collection held at ULITA – An Archive of International Textiles, University of Leeds (UK). Courtesy of Victoria Moore.

the stripes of a zebra). Conventional stripes can thus be classified as regular or irregular, as well as vertical, horizontal or diagonal (depending on the viewing direction). Their width can be denoted by simple measurement of each component stripe within a repeating sequence and the distance (if any) between each component. Regular stripes exhibit a clear repeating sequence, whereas irregular stripes do not.

Further differentiation can be made by varying the numbers of colours used. In the case of regular textile stripes, equal numbers of threads in different colours, following a particular sequence, may be a feature. For example, a regular-stripe sequence may be as follows: four white, beside four light grey, beside four medium grey, beside four dark grey, beside four black, beside four dark grey,

Figure 2.33 Knitted leg coverings. Annual fashion show, Leeds College of Art and Design, May 2008, Royal Armouries, Leeds (UK).

beside four medium grey and beside four light grey; this arrangement would produce a regular balanced stripe going from white, through greys and black, and returning through greys to white, and repeating itself. Such a regular sequence repeated across the width (or length) of the cloth could be denoted as: 4w, 4lg, 4mg, 4dg, 4b, 4dg, 4mg, 4lg. So there is a reflection of colouring, with a reflection line running lengthways in the middle of each group of black threads and in the middle of each group of white threads. In classification, the following general considerations should be noted also: the number of linear components within a repeating unit, including both foreground and background if appropriate; the width of each component; and the disposition or ordering of colours. The ordering of threads mentioned

above can be denoted as 2w, 4lg, 4mg, 4dg, 2b, with 'pivots' (or reflection points) underlined here and indicating that the colouring and associated numbering repeats in reverse order (similar to a system proposed by Stewart, 1974: 32).

A selection of stripe designs, produced by visual-arts-and-design students at the University of Leeds, is presented in Figures 2.34–2.129. In the vast majority of cases, it can be seen that the linear format of the design class is largely upheld, though there is an obvious tendency, in many images, to manipulate the straight-and-parallel forms suggested by convention and thus present the viewer with a composition which retains attention for a longer period than would otherwise be the case.

summary

Lines can be continuous or discontinuous, straight, curved or zigzagged, single, grouped at selected intervals or at random. A sequence of lines may be parallel, though not necessarily straight. Conceptually, lines are of length only and without width, though rendered with width to enable them to be seen. When occurring in a series, stripes may be equidistant or positioned in groups at predetermined intervals, occurring in parallel against a contrasting background. Regular stripes have a series of parallel components (probably colours) which repeat in the exact sequence and scale across the plane. Irregular stripes, common in nature, can be considered as those which show non-systematic (or irregular) repetition of components. Different visual impressions are created by different orientations. Lengthways stripes make objects appear longer and thinner, and widthways stripes make objects appear wider. In the visual arts of ancient times, stripes were an early device applied to pottery, basketry and textiles. In the relatively modern context, stripes can be detected throughout the built, manufactured and natural environments.

Figures 2.34–2.129 Stripe designs, 2014. Courtesy of: Obafunbi Adebekun, Rosanna Adkins, Chaorlotte Allen, Olivia Bambrough, Katya Barton-Chapple, Jessica Bennett, Kate Binns, Zoe Blair, Harriet Bourne, Hannah Brook, Freya Dick-Cleland, Sarah Conn, Amber Druce, Chloe Dunn, Hazel Fletcher, Danice Gilmore, Stephanie Graham, Imogen Henderson, Bronte Jeffrey-Mann, Sophie Johnson, Sian Jones, Pamela Lee, Xiaofan Liu, Emilia Livingston, Claudia Lloyd, Bethany Mackman, Elizabeth Minnis, Harriet Muddiman, William Nichols, Thabata Oliveira, Jacob Parnell-Hogg, Megan Peirson-Shaw, Matthew Proctor, Sophie Proops, Selma Quek, Rachael Stirling, Muxiao Sun, Emily Tyson, Emma Webb, Erika Wilson, Samantha Walsh, Aleksandar Velikov, Bingmi Zhou and Pawel Znojek.

Figures 2.34–2.129 (continued)

Figures 2.34–2.129 (continued)

Figures 2.34–2.129 (continued)

Figures 2.34–2.129 (continued)

Figures 2.34–2.129 (*continued*)

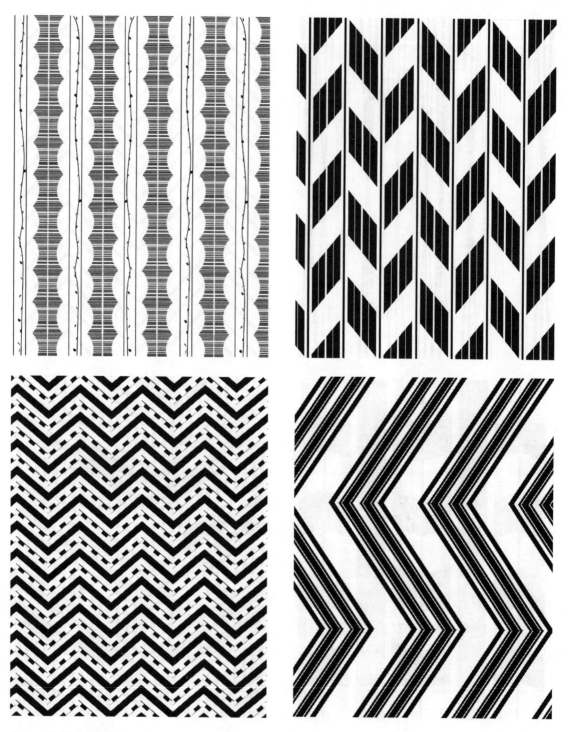

Figures 2.34–2.129 (*continued*)

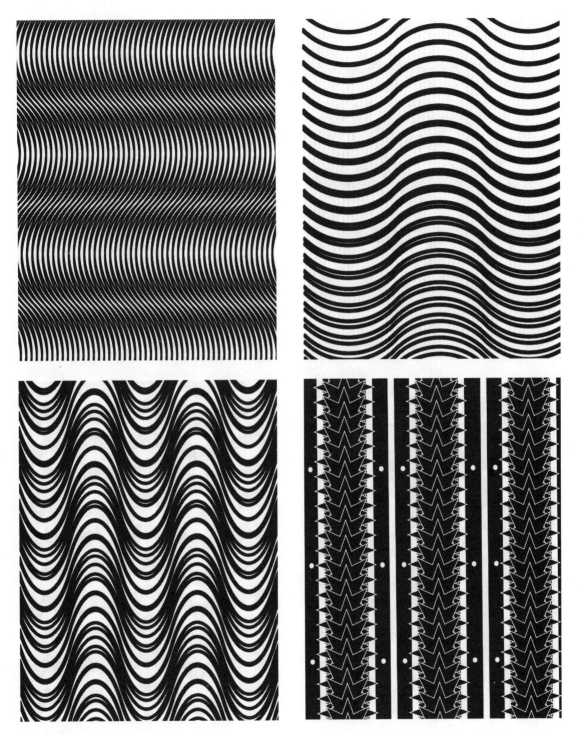

Figures 2.34–2.129 (*continued*)

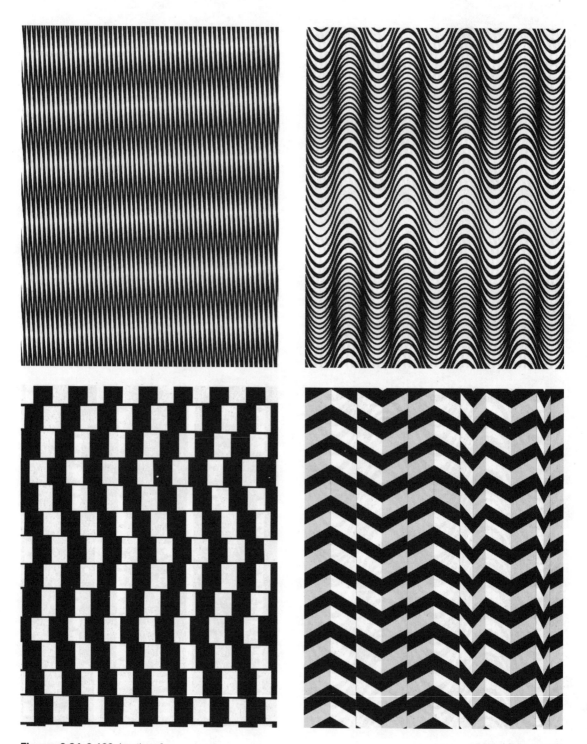

Figures 2.34–2.129 *(continued)*

Figures 2.34–2.129 *(continued)*

Figures 2.34–2.129 (*continued*)

Figures 2.34–2.129 (*continued*)

Figures 2.34–2.129 (*continued*)

Figures 2.34–2.129 (continued)

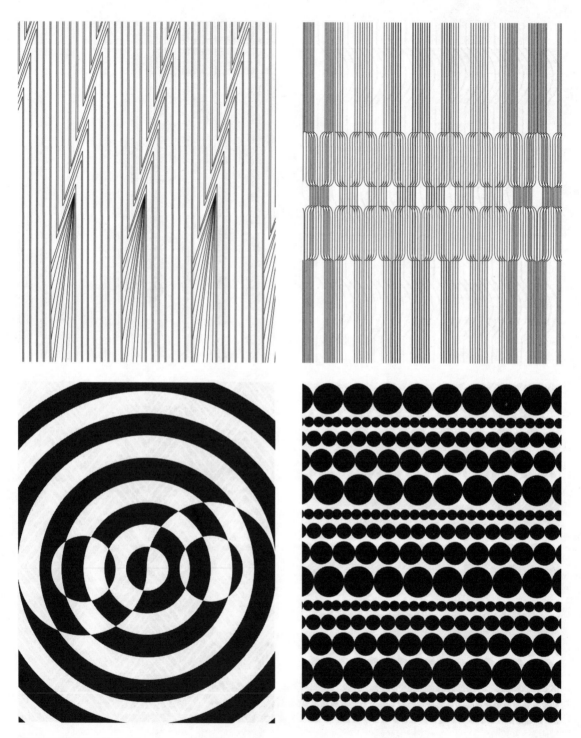

Figures 2.34–2.129 (*continued*)

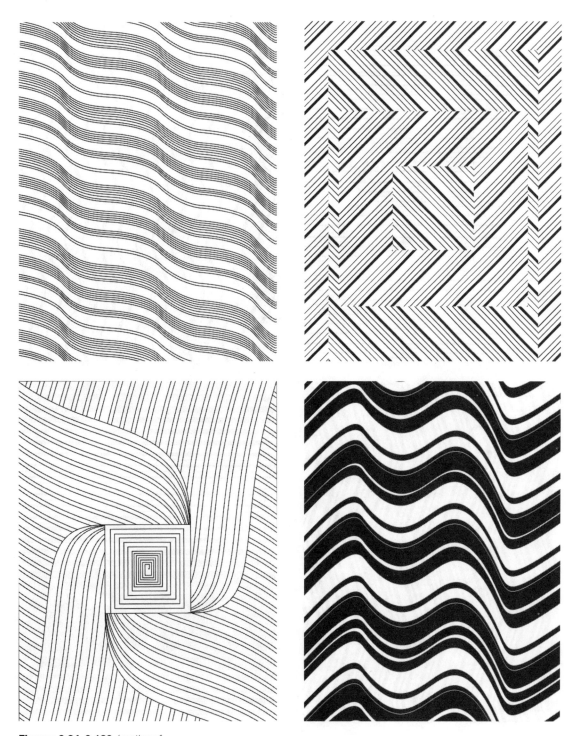

Figures 2.34–2.129 (*continued*)

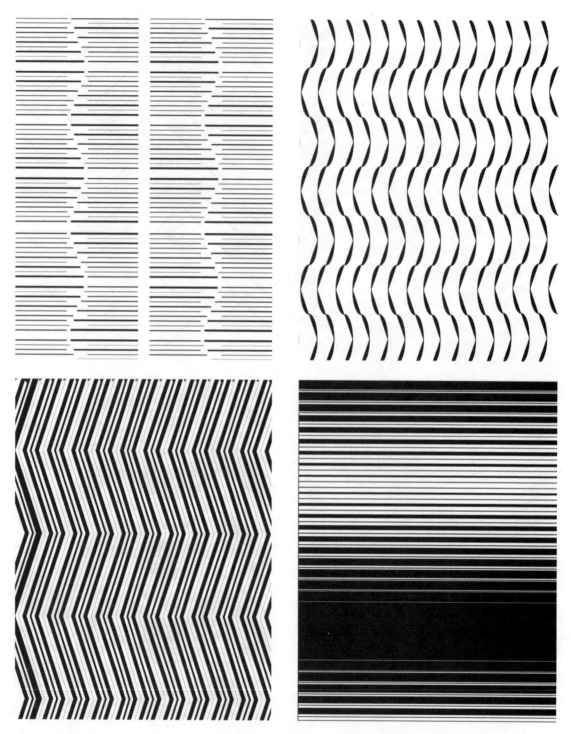

Figures 2.34–2.129 (continued)

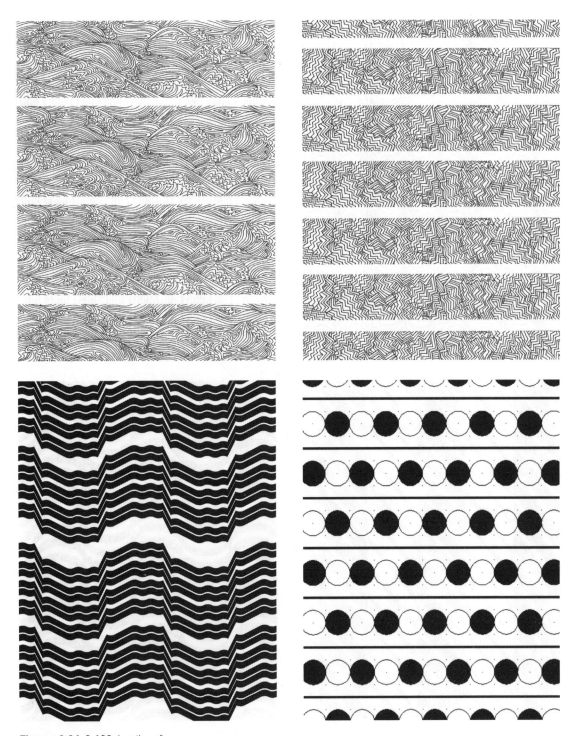

Figures 2.34–2.129 (continued)

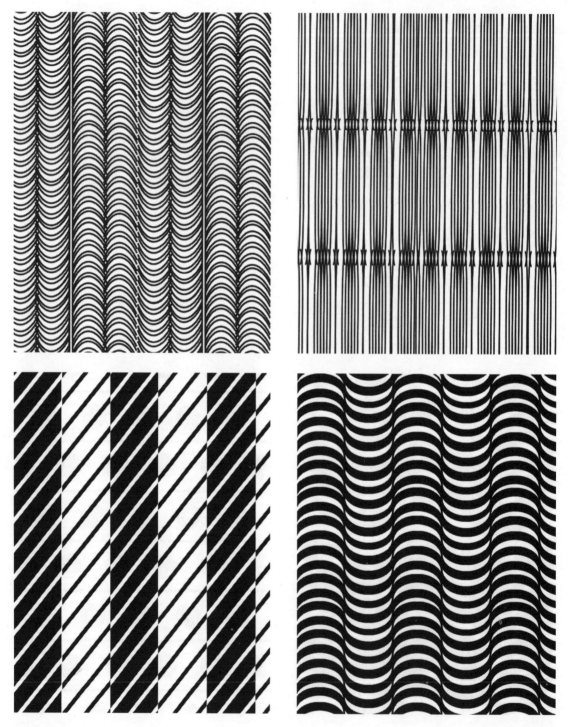

Figures 2.34–2.129 (*continued*)

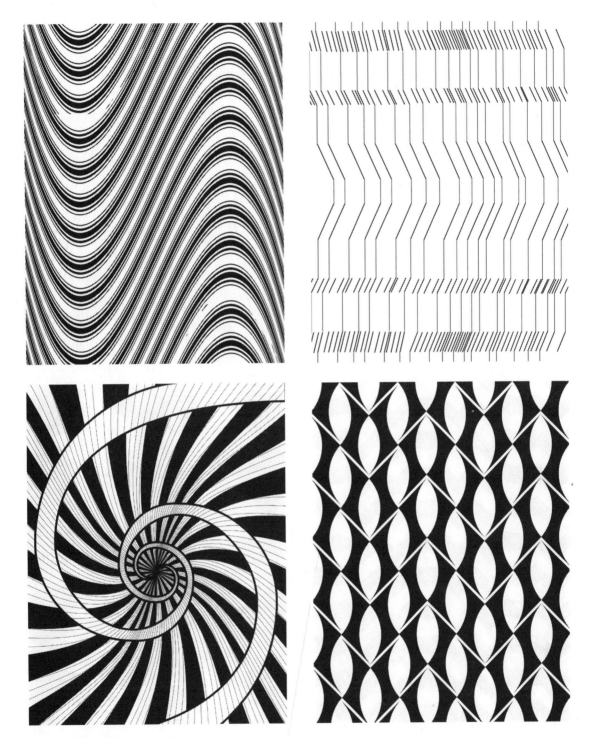

Figures 2.34–2.129 (continued)

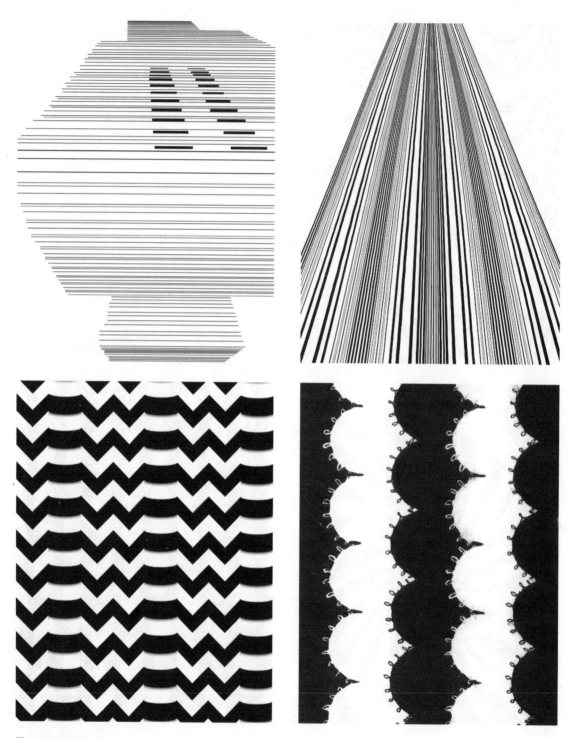

Figures 2.34–2.129 (*continued*)

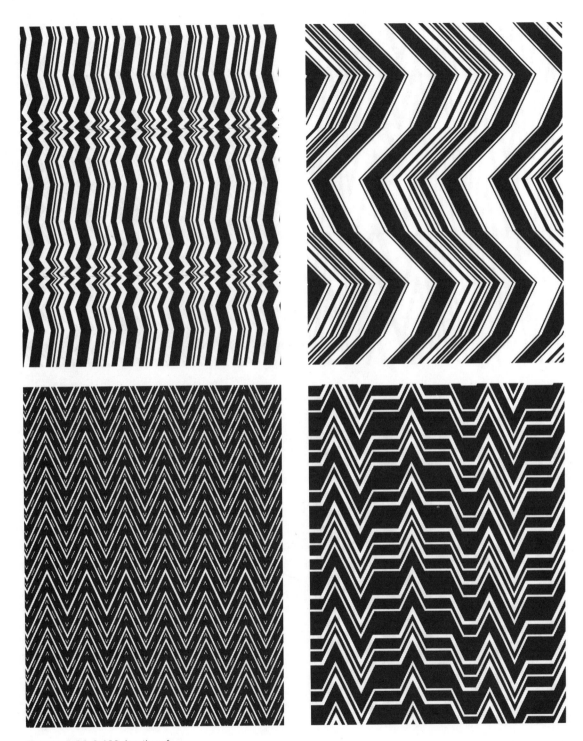

Figures 2.34–2.129 (*continued*)

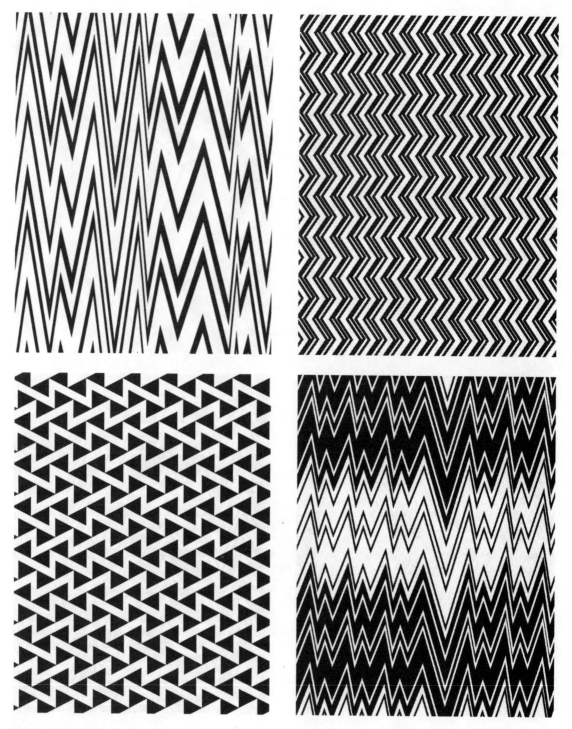

Figures 2.34–2.129 (continued)

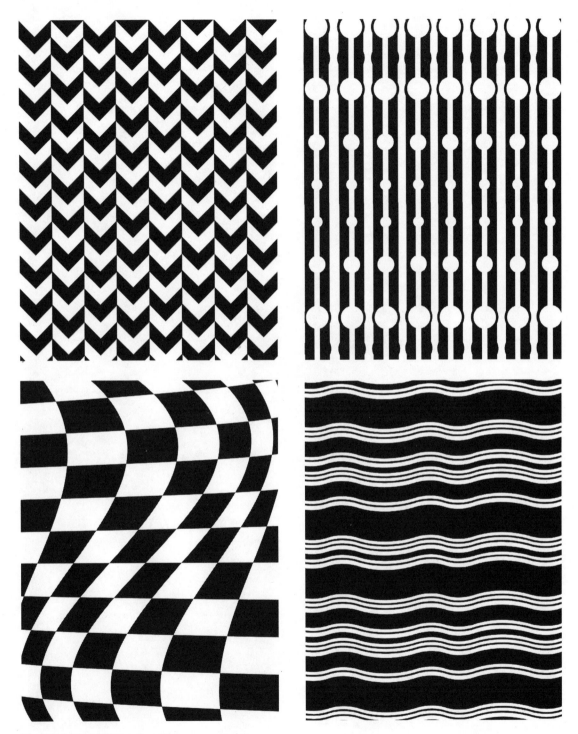

Figures 2.34–2.129 (continued)

3

enclosed figures and forms

introduction

Lines can denote enclosed figures, including circles, ovals and polygons. Enclosed figures can be used as units of larger organized structures known as grids (mentioned in Chapter 1 and considered in further detail in Chapter 5). Lines can be used also as indicators of three-dimensional space, and hence can represent various categories of object known as 'polyhedra', as well as spherical and dome-type constructions.

The importance of symmetry in the natural, constructed and manufactured environments has been recognized by numerous observers, including the present author, who has provided detailed explanations with relevant illustrations (Hann, 2012: 72–96). The concept has been used in the description of various figures and solid forms. Briefly, it can be understood readily that all objects and images are either symmetrical or asymmetrical. Where symmetry does exist, two or more identically sized and shaped versions of each component of the object or image can be identified within the composition, and the placing of each can be visualized most easily in terms of one or two symmetry operations known as reflection or rotation (schematic illustrations of reflection and rotational

symmetry operations are given in Figures 3.1 and 3.2, respectively). Enclosed figures and solid forms can thus be classified by reference to their component symmetry operations. A more detailed classification system, involving further symmetry operations, has allowed the systematic classification of regularly repeating designs including many patterns and tilings. Important contributions were made by Washburn and Crowe (1988), Washburn and Crowe (eds) (2004), Washburn (ed.) (1983, 2004) and Hargittai (ed.) (1986, 1989). An important finding is that when repeating designs from different cultural contexts are analysed with respect to their symmetry properties, it can be seen that different cultures express different symmetry preferences.

Although human experience is set largely in a real three-dimensional world, visualization among designers, even in the early twenty-first century, relies invariably on impressions made by pencil or pen on paper (though computer-aided perceptions of three-dimensional space have gained much acceptance). As observed previously by the present author, certain basic geometrical constructions show a strong persistence historically, and have been of fundamental importance to designers, builders and artists for well over two millennia

Figure 3.1 Reflection symmetry (together with rotation created through intersecting reflection axes) (JSS).

Figure 3.2 Rotational symmetry (twofold to sixfold rotation) (JSS and CW).

(Hann, 2012: 32). A selection of these constructions is identified, described and illustrated in this chapter.

In addition to simple figures such as circles, squares and regular polygons, the importance of certain other constructions such as the so-called vesica piscis, 'Reuleaux polygons' and the 'sacred-cut' square is worth noting. Each has been explained and illustrated previously by the present author (Hann, 2012: 34–37) and is given brief attention here also. The objectives of this chapter are therefore to introduce various enclosed geometric figures, as well as a selection of three-dimensional solid forms. Comment is made also on various types of spatial organization, including radial, clustered, linear, centralized and grid-like arrangements.

circles, squares and triangles

Considered in formal geometric terms, a circle is an area enclosed by a continuous line equidistant from a central point. Circular constructions in various hybrid forms are evident in the natural environment, in crafted, engineered and architectural contexts as well as in urban and rural environments. The circle and its parts are vital components in the construction of many other geometrical figures. Circular forms of design (often referred to as rosettes) can be traced back to ancient times, their importance recognized in ancient Egypt, Babylon, Assyria, Greece and Rome. Circles were used also as frames or guides for the planned division of space in relatively modern times. The halo, a device used in the visual arts to emphasize spirituality, probably has origins with the ancient

Greeks (Hampshire and Stephenson, 2006a: 16). Represented often as a golden light surrounding a subject's head, the halo was transformed during the Italian Renaissance to a ring floating above the head. The deeply held significance of circles among Europeans in ancient times is manifested by stones arranged in circular format in the landscape; Stonehenge (in Wiltshire, England) is a famous example.

An important geometric configuration is the vesica piscis, constructed from two circles of the same radius, intersecting so that the centre of each circle lies on the circumference of the other (Figure 3.3). The construction has been explained previously by the present author, who showed that a particularly important aspect of the vesica piscis was that it acted as a basis for other constructions including various grids of value in tiling designs (Hann, 2012: 34–35). The mysticism associated with the vesica piscis was explored briefly by Lawlor (1982: 31–34).

Certain systems of proportion used historically were based on the square and derivative figures, including the 'sacred-cut' square and root rectangles. The construction of the sacred-cut square has been explained previously by the present author (Hann, 2012: 36–37), and is illustrated here in Figure 3.4. The sacred-cut construction can be continued inwards by repeating the procedure on the inner (sacred-cut) square. Kappraff observed that such a series of sacred-cut constructions may have acted as a system of proportionality in architectural and other constructions in ancient times (2002: 29, 32).

Hampshire and Stephenson acknowledged the usefulness of the square as an 'instrument to measure areas and order information, to generate structure and organize disparate constituents. The square is technical, uniform, a symbol of methodical thought' (2007: 6). A square can also form the unit cell for the most common grid (considered in detail in Chapter 5). Squares are used commonly in puzzles and games (e.g. chess, noughts and crosses, and snakes and ladders, each based on an underlying square grid). A 'magic square' is an arrangement of numbers, presented in an equal number of rows and columns, in grid format. The numbers in each row, each column and in each full diagonal add to the same value. Magic squares can be created in dimensions of 3 × 3 (i.e. a magic square of order 3) and above; an example is given in Figure 3.5. Albrecht Dürer presented a magic square of order 4 in his engraving *Melancholia I*; this is probably the first magic square to appear in European art. Dürer's 4 × 4 numerical format is shown in Figure 3.6.

Josef Albers worked on a series of several hundred paintings entitled 'Homage to the Square'; Charles Rennie Mackintosh, a key exponent of the Arts and Crafts movement, often incorporated a square in his designs; Piet

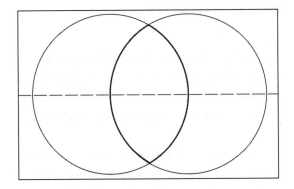

Figure 3.3 Vesica piscis (CW).

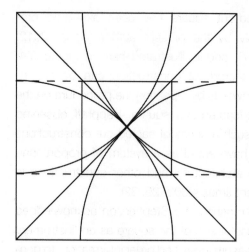

Figure 3.4 Sacred-cut square (CW).

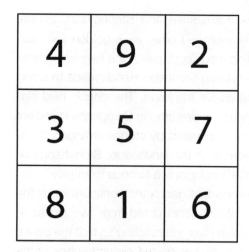

Figure 3.5 A 3 × 3 magic square (CW).

16	3	2	13
5	10	11	8
9	6	7	12
4	15	14	1

Figure 3.6 The 4 × 4 magic square of Dürer (CW).

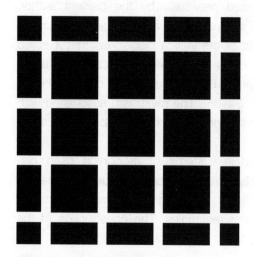

Figure 3.7 Hermann grid (CW).

Mondrian in the early twentieth century created numerous paintings in rectangular- and square-grid formats with unit cells coloured red, blue or yellow, on a white ground. The square has been used to organize information and is found in various forms of classification. Optical illusions using the square (within a grid or in cube form) include the Hermann grid (Figure 3.7) and

the Necker cube, an ambiguous figure or line drawing (Figure 3.8) which can be interpreted visually in one of two ways. Fuller explanation was given by Einhäuser, Martin and König (2004).

A triangle is a three-sided figure, of various types depending on the interior angles and the relative lengths of sides. The most commonly

used triangles in the visual arts and design appear to be: the equilateral triangle, with equal-length sides and equal angles; the right-angled triangle, with sides of lengths 5, 4 and 3, known as the 'Egyptian triangle' (Figure 3.9) and associated with measurements in dynastic Egypt; and the isosceles triangle, with two sides of equal length and two interior angles equal, particularly the triangle with thirty-six degrees as its smallest angle (Figure 3.10), as ten of these of equal size can fit within a circular format (as shown in Figure 3.11); these and other related polygons have been identified and discussed previously by the present author (Hann, 2012: 15–19). The Penrose triangle is an 'impossible object', popularized by Roger Penrose in the second half of the twentieth century (Figure 3.12, with a further development given in Figure 3.13). Such arrangements underpin some of the work of the artist M. C. Escher. Various further orders of 'impossible' polygons can be created (Figures 3.14–3.17) but the degree of ambiguity or 'impossibility' seems highest with the Penrose triangle. A well-illustrated and accessible guide to 'impossible' figures was given by Ernst (1986).

regular polygons

It should be noted that the term 'polygon' is used generally to refer to figures with more than four sides. However, in the context of this book, all enclosed figures of equal angles and equal sides, including the equilateral triangle, which has three equal sides and angles, and the square, which has four equal sides and angles, will be regarded as regular polygons.

Regular polygons are thus enclosed figures, in each case possessing equal-length straight sides (equilateral), and containing equal angles (equi-angular). Higher orders of regular polygon used commonly in the visual arts and design include the regular pentagon, which has five equal-length sides and equal angles; the regular hexagon, which has six equal-length sides and equal angles; the regular heptagon, which has seven equal-length sides and equal angles; the regular octagon, which has eight equal-length sides and equal angles; the regular enneagon, which has nine equal-length sides and equal angles; and the regular decagon, which has ten equal-length sides and equal angles. Various regular polygons are used in combinations to produce tiling designs, considered conveniently as an assembly of polygon shapes which cover the plane without gap or overlap (Hann, 2012: 49–57). Enclosed geometric figures can be split or divided in various ways into simple grids, to provide points of position or as guidelines for locating the visual components of a composition. Elam (2004) provided a comprehensive explanation and discussion of how simple grids could be used as frameworks for visual organization.

spatial organization

As noted by Gombrich, 'There is an observable bias in our perception for simple configurations, straight lines, circles and other simple orders' (1984: 4). This bias appears evident across the full range of visual arts and design, including the organization of architectural floor plans, a topic given much attention by Ching (1996), who

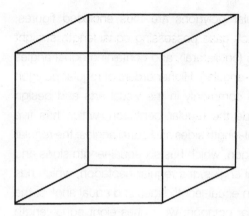

Figure 3.8 Necker cube (CW).

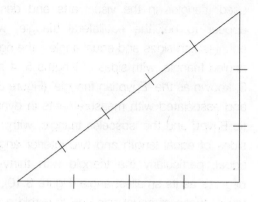

Figure 3.9 The 5, 4, 3 Egyptian triangle (CW).

Figure 3.10 The thirty-six-degrees isosceles triangle (CW).

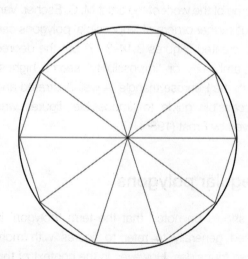

Figure 3.11 Combination of ten thirty-six-degrees isosceles triangles in circular format (CW).

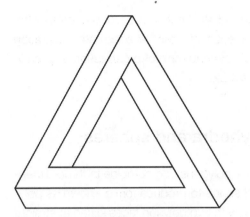

Figure 3.12 Impossible triangle (CW).

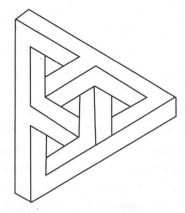

Figure 3.13 A further impossible triangle (CW).

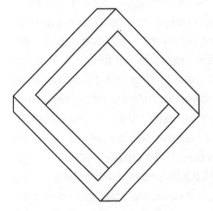

Figure 3.14 Impossible square (CW).

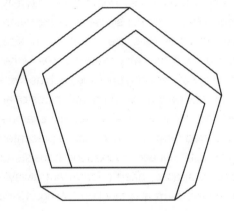

Figure 3.15 Impossible pentagon (CW).

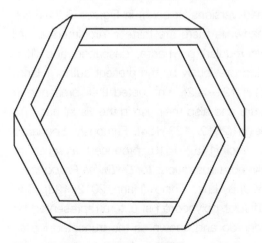

Figure 3.16 Impossible hexagon (CW).

Figure 3.17 Impossible octagon (CW).

differentiated between radial, clustered, linear, centralized and grid forms of organization. The awareness of such compositional alternatives is of value also in other visual-arts-and-design areas. Some of the varieties, identified by Ching (1996), are explained and illustrated below.

Radial organization consists of a central space, often regular in form, with a number of linear 'arms' extending like spokes of a wheel (Ching, 1996: 208). A schematic example of a radial organization scheme is given in Figure 3.18. Clustered organization consists of collections of cells, rooms or spaces in close proximity, with cells often of similar shape and orientation. Where individual cells are dissimilar in size, function or form, they may relate in some further way through an ordering principle such as symmetry or may be organized on both sides of an axis (Ching, 1996: 214). A schematic example of a clustered form of organization is presented in Figure 3.19. Linear organization consists of a series of spaces, often (though not always) equal in size, form and function (Ching, 1996: 198). A schematic example of linear organization (with an added parallel aspect) is presented in Figure 3.20. Centralized floor plans typically consist of a dominant central cell, with a number of surrounding (often equally sized) cells arranged in a regular, often symmetrical fashion (Ching, 1996: 190). A schematic example of a centralized form of organization is given in Figure 3.21. A grid form of organization, also explained by Ching (1996: 220–221), is based on a two-dimensional grid of equally sized square cells or, occasionally, a three-dimensional lattice based on a collection of equally sized cubes. Ching observed that grid forms of organization can undergo transformation based on the sliding of columns or rows of cells or the combination of cells. A schematic illustration of a simple grid form of organization is given in Figure 3.22.

polyhedra and spheres

Various polygons can combine in three-dimensional space to produce forms known as polyhedra, with two polygon faces joined at straight edges and with at least three polygons meeting at corners (or vertices) in such a way as to ensure there is no gap or overlap. There are various types of polyhedron, with the best known falling into the class referred to as the Platonic (or regular) polyhedra (Figure 3.23). It should be noted that polyhedra are sometimes considered in skeleton form (rather than as solid objects) and may be represented consisting of edges and vertices only. There are five Platonic (or regular) polyhedra (comprising the tetrahedron, the octahedron, the cube, the icosahedron and the dodecahedron); these are depicted together with their 'nets' (a term used to refer to the flattened versions of each) in Figures 3.24–3.33. Meanwhile there are thirteen Archimedean (or semi-regular) polyhedra, described and illustrated previously by the present author (Hann, 2012: 121–122), who noted their presence in nature and also their use in the visual arts and design (2012: 123–124). Famously, Leonardo da Vinci (1452–1519) produced a series of polyhedra illustrations for *De Divina Proportione* (1509) by Luca Pacioli (Hann, 2012: 123). One particular polyhedron structure represented by Leonardo and known as the truncated icosahedron (Figure 3.34) is found in a molecular

Figure 3.18 Schematic illustration of radial organization (CW).

Figure 3.19 Schematic illustration of clustered organization (CW).

Figure 3.20 Schematic illustration of linear (and parallel) organization (CW).

Figure 3.21 Schematic illustration of centralized organization (CW).

Figure 3.22 Schematic illustration of a grid form of organization (CW).

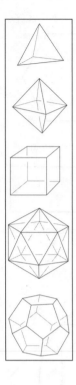

Figure 3.23 The five Platonic (or regular) polyhedra (tetrahedron, octahedron, cube, icosahedron and dodecahedron) (JSS).

Geometric rules governing two-dimensional space are not applicable to the surfaces of spheres. For example, the sum of the interior angles of a triangular shape created on the surface of a sphere exceeds 180 degrees (the angular total possible for any triangle on a flat surface). As noted previously by the present author, a spherical container compared to all other known solid objects can hold the greatest volume per unit of its surface area (Hann, 2012: 115). Knowledge of the characteristics of spheres may be of value to all visual artists and designers working with three-dimensional forms, including product and interior designers as well as architects, sculptors and fashion designers.

Further categories of form have played a role in the development of three-dimensional designs in the past. These include prisms, cylinders, cones and pyramids, and their derivations. These were given consideration previously by the present author (Hann, 2012: 133–136). Attention will be turned briefly in this present book (Chapter 8) to varieties of three-dimensional lattice structures as well as domes and various three-dimensional frameworks (known as space frames), all of which are of relevance to visual artists and designers working in three dimensions.

structure known as C60 Buckminsterfullerene, named due to its resemblance to various dome-like constructions (including geodesic domes) designed by the twentieth-century architect R. Buckminster Fuller (Hann, 2012). Domed structures are given brief attention later in Chapter 8.

A universally familiar three-dimensional object is the sphere, which is perfectly circular when viewed from any direction. The sphere has regular curvature across its surface, and could be considered to have infinite reflection and rotational symmetry about its centre (Hann, 2012: 115). All points on the surface are equidistant from its centre, and a straight line which follows the maximum distance through the object is a diameter. Each sphere may be cut through its centre to create two hemispheres of equal size and shape (Hann, 2012: 115).

summary

In the visual arts and design, there appears to be a persistence of squares, rectangles, triangles and circles. These and related structures have been used for at least a few millennia, possibly acting as frameworks underpinning

structural decisions. A selection of compositional arrangements with origins in architectural theory have been outlined. In the three-dimensional context, various polyhedra and other forms have been introduced; a rudimentary awareness of these is helpful to the understanding of domes and space frames, which will be introduced in Chapter 8.

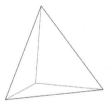

Figure 3.24 Tetrahedron (JSS).

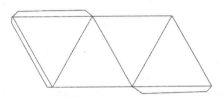

Figure 3.25 Tetrahedron net (JSS).

Figure 3.26 Octahedron (JSS).

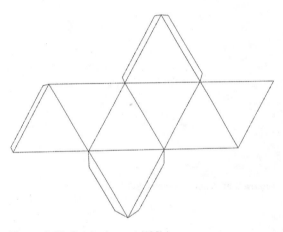

Figure 3.27 Octahedron net (JSS).

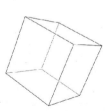

Figure 3.28 Cube (JSS).

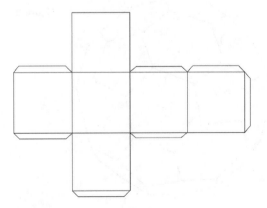

Figure 3.29 Cube net (JSS).

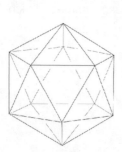

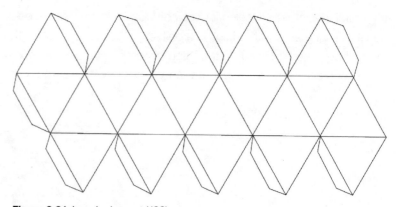

Figure 3.30 Icosahedron (JSS).

Figure 3.31 Icosahedron net (JSS).

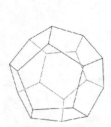

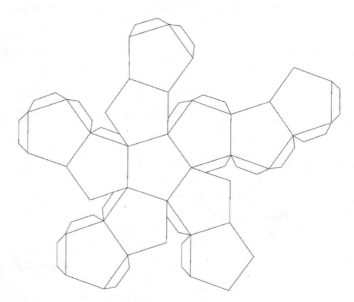

Figure 3.32 Dodecahedron (JSS).

Figure 3.33 Dodecahedron net (JSS).

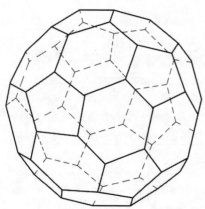

Figure 3.34 The truncated icosahedron (JSS).

4

a question of proportion

introduction

There has been much scholarly debate on the use of systems of proportion in ancient times and their value to practitioners. Systems of proportion are aimed at creating 'a sense of order' (Ching, 1996: 284), and the consideration of such systems has preoccupied theorists and practitioners since the time of the ancient Greeks. Wittkower, a key twentieth-century theorist, traced the European fascination with the concept of proportion back to Pythagoras, Plato and Euclid, and noted that a bibliography compiled by Graf (1958) with nine hundred items listed was 'far from complete' (Wittkower, 1960: 213). Structural proportion, an underlying feature of physical composition, as well as the apparent use of systems or canons of proportion in the visual arts and design are the concerns of this chapter. Several systems of proportion have gained attention historically, with each believed by its proponents to offer a universal truth or insight (Wittkower, 1978: 110). In the twentieth and early twenty-first centuries, proportion and related concepts attracted the attention of numerous scholars, including Cook (1914), Thompson (1917), Hambidge (1920, 1926), Ghyka (1946), Wittkower (1953), Le Corbusier (1950a, 1950b, 1954, 1958), Arnheim (1955), Scholfield (1958), March and Steadman (1971), Gombrich (1984), Neumann (1996), van der Laan (1997), Padovan (1999), Spinadel and Buitrago (2008) and Spinadel and Buitrago (2009).

A brief review is presented in this chapter of a selection of attempts to discover the nature of systems of proportion. Attention is focused on a group of rectangles, known as root rectangles, as well as the so-called golden-section rectangle (or the rectangle of the whirling squares), collectively components of a canon of proportion known as 'dynamic symmetry' proposed by Jay Hambidge (1920, 1926) in the early twentieth century and claimed by him to have formed the basis of visual proportion in the visual arts and design in ancient Egypt and Greece. The Brunés Star, a geometric proportioning (or compositional) device, is explained and illustrated; the Modulor, a system of proportion proposed by the architect Le Corbusier (1954, 1958), is discussed briefly; 'the plastic number', a proportional measure proposed by Dom Hans van der Laan (see Padovan, 1994), is introduced also. Scholarly literature is identified throughout, and associated concepts and perspectives are explained and illustrated.

It is worth commenting at this point that, despite numerous arguments to the contrary found in the wide range of literature identified and reviewed in this chapter, it is the view of the present author that no definitive, all-encompassing single approach to proportion can resolve all problems of structure and form in the visual arts and design. So this chapter does not offer a recommendation to readers to pick up and use one means of ensuring proportional harmony in preference to another. Rather, it is the intention to propose that visual artists and designers should develop an awareness of, and be informed by, the wide range of concepts and principles associated with structure and form, including proportional harmony and the various systems or approaches to proportion identified and discussed in this chapter, and, in particular, should retain this awareness as part of a repertoire or armoury to draw on when confronted with a particular assignment, brief or project.

arithmetical or geometrical

Proportion within a visual composition was described by Scholfield as the relationship of parts to each other and to the whole (Scholfield, 1958: 34). Systems of proportion used to guide this relationship fall largely into one of two categories: commensurable and incommensurable systems. Commensurable systems are based on whole numbers and associated ratios (e.g. 1:2, 4:6 or 8:12), whereas incommensurable systems are based on geometric measures (1:√2, 1:√3 or 1:√5) achieved through geometrical construction rather than

arithmetical calculation. A good concise historical review of both systems was provided by Scholfield (1958: 126–128). It has been argued that in medieval Europe (particularly in cathedral architecture) the preference was for geometrical (or incommensurable) systems of proportion, while in the later Renaissance period the preference (with some exceptions) was for arithmetical (or commensurable) systems of proportion (Wittkower, 1978: 116–117). A readily understandable explanation of both systems was given by March and Steadman (1971: 222–241, 346).

In the context of the visual arts and design, the most common usage of the term 'proportion' is where one shape relates to another and each relates in some way to the whole (Figure 4.1). So shape 'a', for example, is similar in outline to, though different in scale from, shape 'b', and both relate to shape 'c'. A rectangle of dimensions x by y (rectangle 'a', say 100 mm

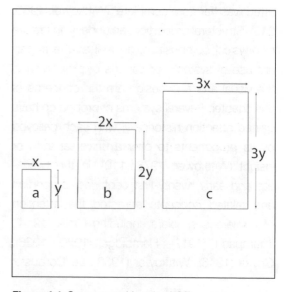

Figure 4.1 Commensurable ratios (JSS).

by 150 mm) can be said to be in proportion to a rectangle of dimensions 2x by 2y (rectangle 'b', 200 mm by 300 mm), and each can be said to be proportional to a larger rectangle of dimension 3x by 3y (rectangle 'c', 300 mm by 450 mm). The ratio of the width x to length y in rectangle 'a' is equal to that between width 2x and length 2y in rectangle 'b', and equal to that between width 3x and length 3y in rectangle 'c', or expressed in equality of ratios, $x:y = 2x:2y = 3x:3y$. With such a system we can envisage readily that other possibilities could unfold through constructing rectangles with sides of one-fourth or one-fifth those of rectangle 'c', for example. Such ratios are regarded as commensurable. An example of incommensurable proportions is the series of root rectangles illustrated later in this chapter.

Wittkower commented that 'many of the geometrical proportions cannot be expressed by integral numbers or simple fractions … In the equilateral triangle, for instance, the height (i.e. the perpendicular) is incommensurable with the length of the sides and can only be expressed by the square root of three' (1978: 116). Probably the most notable incommensurable system of proportion is that associated with the 'golden section', the focus of attention in the fourth section of this chapter. It is worth remarking that in practice, particularly in the context of building construction, the tendency is to use rounded-off measures. Rather than specifying a measure such as √2, a figure of 1.4142 would be stated, and this might well be rounded off further to 1.4: so the incommensurable is made commensurable. A particularly thorough review of the nature of proportion was provided by Padovan (1999).

evidence for past use

There has been a wealth of published studies focused on determining the use of systems or canons of proportion during various historical periods. Studies of ancient Egyptian art have been particularly numerous, and a small selection of these is reviewed below. An early example was MacKay (1917), who, making reference to various Theban tombs, explained how a squared grid was used and how standing and seated figures related to the grid, and argued that a grid ensured consistent proportions in representations of human figures. In the second half of the twentieth century, the work of Iversen (1960, 1968, 1976) holds a place of importance. In fact, Iversen's work came to be regarded as the standard study of Egyptian art, and its use of grids. Lorenzen (1980) presented an appraisal of a rectangular wooden drawing board held in the Egyptian-antiquities collection of the British Museum, and maintained that consideration of this object confirmed the use of a canon of proportion in association with a square-grid structure. Smith and Stewart considered a drawing of an ancient Egyptian portable temple shrine drawn in black on a grid of squares in red, dated within the period 1490–1140 BCE; they commented: 'Comparison of this grid with the proportion-grid used by Egyptian artists for constructing the human figure … shows that the number of squares (18) used for the height of the human figure to the hair-line is the same as the number of squares (18) used … for the unadorned external height of the shrine' (Smith and Stewart, 1984).

Robins (1985, 1991, 1994a, 1994b) provided several contributions. She observed that

the early Egyptian grid system, in use from the twelfth to twenty-fifth dynasties, used 18 squares on a grid from the soles of the feet to the hairline, and 14 squares to represent seated figures (Robins 1991). In a later grid type, first used in the twenty-fifth dynasty, standing figures were drawn on 21 squares (between the soles and the upper eyelid) and seated figures on 17 squares. In her book *Proportion and Style in Ancient Egyptian Art* (1994b), Robins provided a comprehensive study of structure in ancient Egyptian art, and maintained that grids acted as the basis for a canon of proportion and indicated to the craftsperson the relative positions and sizes of bodily features to be depicted on a final working surface. So the knee or the waist or the neck would be positioned respectively a given number of squares within the grid above where the ankle was located. It is well established therefore that grids were in widespread use in ancient Egypt, and the bulk of research supports the proposition that such grids were used in association with a canon of proportion.

According to Erickson (1986), European views on the use of various systems of proportion during medieval times have their origins in the work of a first-century Roman architect and engineer by the name of Marcus Vitruvius Pollio (translation by Morgan, 1960) who 'refined Plato's ... concepts of symmetry and proportion and applied them specifically to architectural design' (Erickson, 1986: 211). Kelly (1996) considered the geometrical characteristics of a selection of Columban crosses in Ireland and Scotland, and found the frequent use of $1:\sqrt{2}$, which she commented may have had its origins in Vitruvian views on ideal proportion (Kelly, 1996: 139). Williams (1997)

maintained that 'Renaissance architects paid particular attention to systems of proportion believing that in these lay the key to architectural excellence', and observed, first, that the Romans were familiar with the proportion $1:\sqrt{2}$, and second, that 'Vitruvius specifically recommended the root-2 rectangle as one of several suitable shapes for the atrium of a house'. This measure was revealed also in Williams's study of the proportions of Michelangelo's Medici Chapel, which was believed to have been constructed by reference to 'a geometric system based upon the irrational square root of two' (Williams, 1997). Cohen (2008), in his study of late medieval proportion systems in the Basilica of San Lorenzo in Florence, noted a frequent use of the ratio $1:\sqrt{2}$.

Various studies have focused on discovering the underlying proportion or 'the existence of a special form of geometry' (Dudley, 2010: 11) in churches, temples and other religious buildings and monuments. Dudley (2010) provided a broad-ranging review, dealing with the developing knowledge of building geometry from ancient and early medieval times to the building of the Gothic cathedrals of Europe, and focused particular attention on Canterbury Cathedral (in south-east England). Case studies of Gothic architectural geometry, including consideration of the application of systems of proportion, were provided by Saxl (1946), Prak (1966) and James (1973, 1978). A useful series of articles, focusing on the tools, methods and knowledge of medieval masons, was provided by Shelby (1961, 1964, 1965, 1970, 1971, 1972, 1977, 1979). Cowan's (1979) monograph on the rose windows of European Gothic cathedrals provided a well-illustrated discussion of their development,

their function and their underlying geometry. More recently, McCague (2003: 11) considered the mathematics that may have been used by medieval stonemasons in the construction of Durham Cathedral (in north-east England). So, from these and other studies, it is evident that various systems of proportion have gained attention over the years. A selection of these systems is considered in the following sections.

Figure 4.2 Golden-section construction (AH).

the golden section

In his treatise *Mysterium Cosmographicum* (1596), Kepler (1571–1630 CE) proclaimed that a 'precious jewel' of geometry was a line divided into two unequal lengths such that the length of the original line is to the longer of the two cut lengths as the longer cut length is to the shorter cut length, a measure that has become known as the 'golden section' (Huntley, 1970: 23; Fletcher, 2006). The golden section is thus a ratio of one length to another (Figure 4.2). An early treatise dealing with relevant subject matter is *De Divina Proportione* (1509) by Luca Pacioli (1445–1517) (Huntley, 1970: 25; Olsen, 2006: 2), a work illustrated by Leonardo da Vinci, who, tradition claims, used the term *sectio aurea* or 'golden section' (Olsen, 2006: 2). By the twentieth century, the Greek letter Φ (phi) was used widely to denote a numerical value which approximates to 1.6180. The golden-section ratio is expressed generally as 1:1.6180. Phi can be derived in various ways and is reputed to manifest itself throughout the natural and manufactured worlds, though it should be stressed that there are many eminent scholars who have

presented convincing reviews identifying some of the misconceptions that have built up in the literature and proliferated on websites over the years. During the nineteenth century, the concept was popularized by Zeising (1854), and later by Fechner (1871), whose investigations suggested the aesthetic appeal of rectangles whose sides are in the golden-section ratio. Golden-section research, during much of the twentieth century, appears to have been influenced deeply by scholars examining patterns of growth in natural phenomena; the foremost examples were Cook (1914) and Thompson (1917). A comprehensive review of golden-section-research literature (mainly from the realms of psychology) was provided by Green (1995). A good concise review, from the discipline of marketing, was provided by Raghubir and Greenleaf (2006). Ghyka ([1946] 1977), Pierce (1951), Huntley (1970), Doczi (1981), Lawlor (1982), Elam (2001), Livio (2002) and Hemenway (2005) represent an informative cross-section of literature on the subject. Various articles by Fischler (1979, 1981a, 1981b), Benjafield (1985), Markowsky (1992), Russell (2000: 40) and Huylebrouck (2009) are worth attention.

A particular numerical series, which has become known as the 'Fibonacci series' (1, 1, 2, 3, 5, 8, 13, 21, 34, 55, …), is associated closely with the golden section. When each successive number (after 3) in the series is divided by its predecessor, the result will approximate to 1.618. For example, 8 divided by 5 is 1.60. The further up within the sequence, the closer the two successive numbers (one divided by the other) will approach the golden-section value of 1.6180 (or, more precisely, 1.6180339887). A golden-section rectangle can be constructed from a square (Figure 4.3). Further constructions, including the golden-section spiral, can be created within this initial rectangle (Figure 4.4); fuller explanation was given previously by the present author (Hann, 2012: 109–111).

dynamic symmetry

Hambidge (1920, 1926) introduced various rectangular constructions known as root rect-

angles (Figure 4.5), and a golden-section rectangle which he referred to as the 'rectangle of the whirling squares' (Figure 4.6). When used in the visual arts and design, such rectangles constituted what he called 'dynamic symmetry', a particular system of compositional organization which he claimed had been applied by both the ancient Egyptians and the ancient Greeks. Meanwhile, static rectangles were the basis of 'static symmetry' and were created by dividing a rectangle into simple multiple parts, such as quarters, thirds, sixths and eighths, and combinations of these; such (arithmetical) proportional arrangements as the latter were deemed by Hambidge to offer inferior compositional possibilities. Ghyka ([1946] 1977: 126–127), a great supporter of Hambidge, believed there was a clear advantage in combining dynamic-type proportions from the same parent sources and using these together within the one composition.

The validity of Hambidge's findings, which were based principally on the examination of

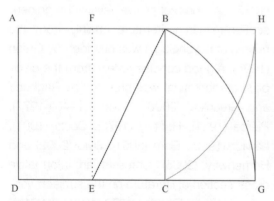

Figure 4.3 Golden-section rectangle (AH). Construction as follows: bisect side CD of square ABCD at E and side AB at F. Draw line EB. With E as centre, draw arc BG. Extend DC to G. With F as centre, draw arc HC. Extend AB to H. Complete the rectangle with sides in the ratio of 1: 1.6180.

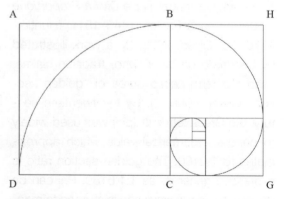

Figure 4.4 Golden-section spiral (AH).

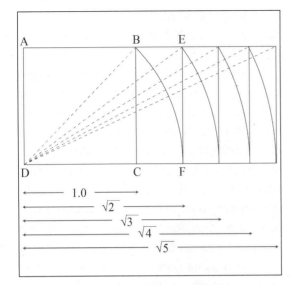

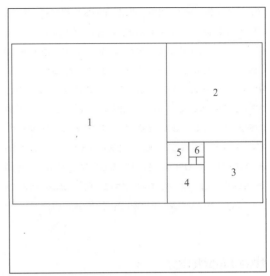

Figure 4.5 Successive root rectangles (JSS).

Figure 4.6 Rectangle of the whirling squares (CW).

various ancient vases, was, however, the subject of much further debate. Edwards (1967: 8), for example, on making reference to Hambidge's proposals, claimed that, whereas 'the sum and substance of dynamic symmetry rests on the principles of continued proportion and of divisibility into similar shapes', such characteristics 'are inherent in any rectangle'. So while Hambidge contended that the root rectangles and the 1:1.618 (golden-section) rectangle and its derivatives alone were components of the dynamic system, Edwards maintained that such a system was available through the use of any rectangle. In essence, Hambidge argued that the use of dynamic symmetry, based on measurements associated with root rectangles and the rectangle of the whirling squares, ensured desirable physical proportions of manufactured objects, constructions or other creations.

Richter (1922) addressed various criticisms of Hambidge's earlier (1920) work and presented a guarded statement of support, though, at the same time, underlining the necessity for substantially more evidence. Probably the strongest degree of support for Hambidge's views was provided by Caskey (1922a, 1922b) in his study of the geometry of Greek vases. However, the severest criticism seems to have come from Blake, who stated that 'in spite of the enthusiasm with which dynamic symmetry has been received, there is little ground to support the claims made of it' (Blake, 1921: 127). More recently, the present author argued that root rectangles offered potential as compositional aids to the creative practitioner and also presented a series of grids based on unit cells derived from dynamic rectangles (Hann, 2012: 46–47). Importantly, these proposed additions to the repertoire of the creative visual

practitioner were intended to sit alongside a range of geometric frameworks and grid types, thus avoiding the tendency 'for researchers to believe that the one system of proportion which they have adopted as their focus is the one and only system of any value' (Hann, 2012: 41). The present author is of the view that knowledge of the series of root rectangles offers access to a potentially useful system of proportion and is worth adding to the structural repertoire of modern-day visual artists and designers.

the Modulor

Towards the mid-twentieth century, it was the work of Le Corbusier, the eminent architect, that held centre stage in the debate relating to proportion. In his publication *The Modulor*, Le Corbusier presented a system (known also as the 'Modulor') based on numerical series associated with human scale as well as the related golden-section ratio and Fibonacci numbers (Le Corbusier, 1954: 55). Graphically, the Modulor is illustrated by a stylized, six-foot-tall, male human figure, with one arm raised, beside two vertical measures, one known as the blue series (associated with the figure's height) and the other as the red series (associated with the height of the figure's navel), each segmented by reference to the Fibonacci series (Livio, 2002: 173–175). Over the years, there has been much criticism of the usefulness of the Modulor to designers. It is perplexing that supporters of the system do not appear to have turned attention to the production of an equivalent system based on a female figure. It is worth noting that a reprinted edition of *The Modulor* (1954) and

Modulor 2 (1958) was published at the beginning of the twenty-first century (Le Corbusier, 2000).

Neumann (1996: 217) observed that whether or not systems of proportion were of value appeared to have been answered to the satisfaction of many as a result of the outcome of a debate organized at the headquarters of the Royal Institute of British Architects (RIBA), London in 1957; the motion debated (and lost), derived from a remark reputedly made by Einstein after being given an explanation of the Modulor by Le Corbusier, was that 'systems of proportion make good design easier and bad design more difficult' (Anon, 1957). Despite the view expressed by Neumann in the late twentieth century, the Modulor continued to attract the attention of design educators, students and practitioners in the early twenty-first century. It appears to be the case that knowledge of the Modulor and its development by Le Corbusier has stimulated an awareness of the structural aspects of design and has contributed to encouraging a systematic approach to visual proportion in general. For this reason, the student reader is encouraged to seek out further knowledge of Le Corbusier's system and possibly also to develop related systems of proportion for use in future assignments or projects.

the Brunés Star

There has been much debate over the historical use by visual artists and designers of a construction which has become known as the 'Brunés Star', named after Tons Brunés (1967), a Danish engineer (Figure 4.7). The construction,

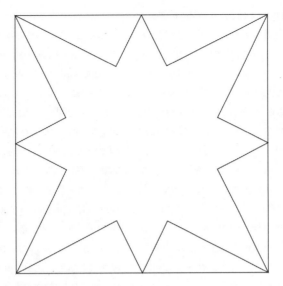

Figure 4.7 Brunés Star outline (JSS).

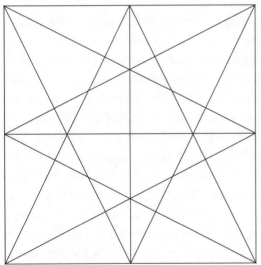

Figure 4.8 Brunés Star divisions (JSS).

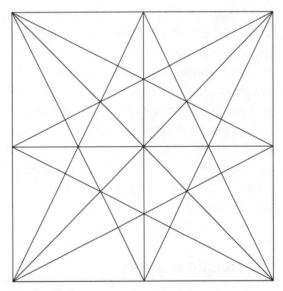

Figure 4.9 Brunés Star with full diagonals (CW).

which can take the form of an underlying structural device, is created through the subdivision of a square into four equal component squares and the addition of various half diagonals (Figure 4.8) as well as further full diagonals

(Figure 4.9). A comprehensive explanation of this and associated constructions, as well as their use in antiquity, was provided by Kappraff (2000: 26–38). A well-illustrated treatise, presenting evidence which indicated the use of the

construction historically in parts of both Europe and Asia, was provided by Stewart (2009). A range of associated constructions was proposed and illustrated previously by the present author, and it was argued that such constructions could play a role in visual-arts analysis and may also act as a basis for a framework of value to practitioners (Hann, 2012: 42–44). The use of the construction as a proportional device in ancient times was highlighted by Kappraff, who concluded that 'The Brunés star with its ability to approximately square the circle … its relationship to 3, 4, 5-triangles, and its ability to be generalized to a geometrical figure exhibiting the golden … mean makes it a plausible tool for use of the builders of ancient sacred structures' (Kappraff, 2000: 36). On the basis of the views of Kappraff and others, it appears that the Brunés Star and related constructions may prove of immense value to both visual-arts-and-design practitioners as well as analysts. The principal reason for this appears to be that the device, when held within a square, can express several directions of reflection symmetry and has thus been 'detected' in numerous historical works of art (as highlighted, for example, by Stewart, 2009).

the plastic number

Padovan reviewed literature concerned with proportion in architecture, art and nature and focused particular attention on the work of Dom Hans van der Laan. The term 'plastic number' (or *plastische getal*, in Dutch) was coined in 1928 by Dom Hans van der Laan, an architectural theorist and practitioner who also pursued a vocation as a Benedictine monk. The work of Padovan (1994, 1999, 2002) has played a major role in bringing van der Laan's theoretical perspectives to the attention of a wider academic audience. In practice, proportion is related closely to perception, and van der Laan was concerned with the perception of three-dimensional shapes and, in particular, with identifying the conditions which allowed the classification of objects into size categories. So given a group of say twenty objects of the same colour, texture and shape, all of different sizes, it appears that the ratio of the size of one object to another to enable them to be placed readily by the observer in different size classes is 3:4. It is also necessary that the largest object in the group differs from the next largest by no more than the size of the smallest member of the group of twenty objects. Also it appears that, in order to classify the group of twenty objects, a system consisting of seven classes is ideal. From these findings, van der Laan developed a theory of proportion not following other proportion systems, which seem to be based largely on structural rules associated with forms of growth or growth sequences in nature (typified often by reference to natural spirals of various kinds found, for example, in seashells, ferns, sunflowers or pine cones), but based rather on the consideration of human perception. Proietti (2012) observed that 'it is a proportional system imposed upon nature rather than extracted from it' (Proietti, 2012: 107). The value of 1:1.324718 (or approximately 3:4) is regarded as the plastic number and is associated with the following numerical series proposed by van der Laan: 1, 1, 1, 2, 2, 3, 4, 5, 7, 9, 12, 16, 21, … (Proietti, 2012).

The rather obscure rule of the series (at least from the viewpoint of the non-mathematician) is that each number is obtained by skipping the number immediately previous and adding together the two numbers previous to that. Knowledge of the nature of the plastic number does not appear (at the time of writing in late 2014) to be widespread among visual artists and designers (including architects). An important aspect to stress is that the system was developed taking into account human perception of objects in three-dimensional space; so the particular applicability appears to be in the realms of architectural and other forms of three-dimensional design. Substantial further explanation was given by Padovan (1999).

summary

It seems highly likely that in ancient times, before the development of mathematical knowledge of the type classified under headings such as 'geometric' or 'arithmetic', craftspeople, builders or others may have created objects or other visual compositions with little or no mathematical knowledge. Subsequently, when such mathematical knowledge was acquired by others, there may have been a tendency to measure what had already been created. In early times, therefore, it seems likely that arithmetical and geometrical theory were (at best) secondary considerations, and constructions were based largely on practical knowledge passed from the accomplished master craftsperson to apprentice; it is probable that, at a later stage historically, arithmetical and geometrical considerations were adopted because they provided convenient shortcuts for initiated (i.e. knowledgeable) craftspeople and builders to follow. Also, there may have been a tendency to shroud building knowledge in a code of arithmetic and geometry known only to relevant tradespeople, who had sufficient reading, writing and numeracy skills as well as a basic understanding of geometric drawing and constructions. Ease of access was thus denied to the uninitiated.

From a brief review of the literature, it is apparent, first, that each of the systems of proportion reviewed has its supporters and detractors and, second, that no convincing evidence appears to have been published which confirms that any one particular system of proportion (such as the golden section or the plastic number) is all-encompassing and superior to all others. It may well be the case that, when visual artists approach composition in a systematic way, the results obtained are more visually satisfactory and resolved than would be the case otherwise. It is worth calling to mind a comment made previously by the present author that harmony between the various parts of a visual composition often results when the individual components relate in some close way, that is they are in 'proportion' to each other though they may be of unequal size, area, volume or dimensions (Hann, 2012: 161). It has been believed for centuries that when the parts within a composition are in proportion to one another, then balance and harmony result.

Although awareness of systems of proportion is not lacking among many visual artists and designers in modern times, there appears to be strong hesitancy in incorporating such systems into practical everyday use. In the

modern context, it is worth calling to mind a comment made to the present author by a highly experienced senior architect when discussing the advantages and disadvantages of using systems of proportion in architecture: 'At the end of the day, you need to consider the thickness of the brick' (Byrne, 2014); this highlights that modern systems of architecture rely on building materials available in certain standard measurements only, and that using a particular system of proportion may be compromised by the simple necessity to use what is available at a given cost. Despite the restrictions imposed by the pre-cut measurement of raw materials, there still appears to be an ample role for proportion in modern design. The present author's view is that modern visual artists and designers should develop an awareness of various systems of proportion and should incorporate these into a repertoire for achieving balance, harmony and visual resolution. What appears to be crucial, judging even from a cursory review of past great achievements in the visual arts and design, is that success is not achieved through accidental endeavour but rather through a determined systematic approach by individuals or teams fully aware of alternatives. By way of further comment, however, it is worth noting that while success in the visual arts, through the use of mathematical systems of proportion, appears to be applauded in much of the literature, the precise connection (if any) between success and the use of one or another system of proportion is far from clear. There seems to be the need for research which asks current visual artists and designers whether or not they consciously use underlying morphologies in their creative work.

5

grids – guidelines, frameworks and measuring devices

introduction

As noted previously in Chapter 1, lines may be assembled to create grids, considered often to be those two-dimensional structures which consist of two sets of parallel lines, one superimposed on the other, often at ninety degrees. Grids appear to have fulfilled a range of functions over the years. The objectives of this chapter are to introduce and define relevant terms and to review briefly the role played by grids, both historically and in modern times, in underpinning visual compositions of various kinds.

definitions and types

In figurative as well as non-figurative visual compositions, grids have been employed to determine the positioning of constituent elements. In the case of a square or rectangular format (such as a double-page magazine spread, a photograph or a painter's canvas), the grid may consist simply of a set of two parallel vertical lines superimposed at ninety degrees on a set of two parallel horizontal lines, thus creating nine rectangles (or three-by-three divisions). The composition is then created (or edited) by

reference to these nine rectangles, possibly with dominant elements positioned either within the central rectangle or at one of the four central intersection points created by the two sets of intersecting lines (e.g. Figure 5.1). Ambrose and Harris (2008) carried out a wide-ranging review of the subject, identifying how grids have been used as guides in the placing of design elements across several graphic-design areas. Taking a simple square format as an example, Elam (2004) demonstrated the numerous

Figure 5.1 Simple three-by-three grid on a square composition. Courtesy of Josh Caudwell.

alternatives available to the designer when making compositional decisions involving the placing of blocks of text using the simple three-by-three division of a square. A useful review of techniques and approaches used in layout design was provided by Samara (2005). In the context of this present book, the word 'grid' is used to refer to two-dimensional assemblies of lines running in at least two distinct directions, which act as a guide to the placing of components of a design or other visual statement.

range of applications

Williamson (1986), who defined a grid as 'a proportional system of coordinates intersected by vertical and horizontal axes', considered its use as a guideline for the positioning of text and images in late-medieval (fifteenth-century) European manuscripts. It seems that the use of vertical and horizontal lines as an underlying structure, guiding the positioning of text and images, during medieval times (and probably before) did not differ substantially from the use of grids to regulate page layout in relatively modern times (for example, in newspapers, magazines, posters and web pages). As observed by Williamson (1986), visual analysis of European medieval manuscripts suggests that grids fulfilled a representational and symbolic purpose as well as aiding decisions relating to organizing the composition, aligning edges and objects and regulating widths for lines of text. Representational and symbolic positioning of text and images, similar to that practised in medieval times, is sometimes a feature of visual composition in modern times

as well. Occasionally, political preferences or messages may be expressed through allowing selected images or text to dominate the layout of newspaper or magazine pages.

In centuries past, global exploration and discovery required precise marine navigation, and this was aided by insights from the Flemish mathematician and cartographer Gerardus Mercator, who proposed a grid with mathematically determined coordinates, with longitudinal and latitudinal axes and with accurate representations of physical distances (Williamson, 1986). Perspective grids were introduced also in Renaissance Europe. Williamson (1986) observed that, like Mercator's cartographic grid, mathematical perspective grids gave a representation of spatial relationships between physical points on a plane.

Grids were used in medieval and Renaissance Europe as a means for transferring the details of a small sketch (or cartoon) on paper to large painting surfaces such as plaster wall areas (Davis, 1972). A cartoon or outline was drawn on to a grid (probably with square unit cells created by two systems of parallel lines at right angles to each other) on a sheet of paper. Meanwhile, the larger-scale surface to be painted was split into the same number of equally sized squares, with each of a larger size compared to the squares of the sheet of paper. The drawing or outline was then reproduced one square at a time with the drawing lines in the small squares being redrawn, with the same directional orientation and to larger scale, in the bigger squares.

Series of vertical and horizontal lines may have been used also as guidelines in composition, particularly as a means of determining

verticality and horizontality, as well as the plac-ing of motifs or other components, simply to ensure that they fitted within the physical boundaries of the surface being worked on. A further compositional role of such grids may have been as a guide to visual accuracy and the application of reflection symmetry to compo-nents within a composition; the near universality of reflection symmetry in the natural and manu-factured worlds is well known, and simple grid forms would have been a convenient guideline and means of ensuring convincing representa-tion of relevant subject matter. The high degree of image symmetry in some Italian Renaissance paintings (e.g. Raphael's *The School of Athens*) suggests to the present author that horizontal and vertical guidelines, probably in grid form, were in common use among visual artists.

Collins (1962) considered the possible ori-gins of the use of 'graph' (or squared) paper in twentieth-century architectural design and noted early usage in eighteenth-century France, where squared paper was printed specifically for use by silk weavers in Lyon to denote the disposition of patterning to be brought about by the raising of warp threads above weft threads during the weaving process. He noted further that line spacing in early examples of silk weavers' squared paper often varied con-siderably, as exact measurement of compo-nent squares was not a crucial requirement. Rather, selected (or inked-in) 'squares' simply indicated the order of raised warp threads dur-ing the weaving process, and squared-paper drawing was by no means a scaled version of the final woven fabric; often, the constituent unit cells would be non-square rectangles of various dimensions. Collins (1962) commented:

'Exact measurement was unnecessary since the drawn patterns were neither the same size as, nor mathematically scaled to, the pattern which appeared on the finished silk.' Despite this, it seems that squared paper intended for recording woven-silk designs was adapted to architectural-design uses, even though scaled precision was crucial to architectural designs (Collins, 1962). There appears to be some evidence, however, for the use of types of portable squared surfaces (of paper or other material) in architectural design in the centuries prior to squared paper being adapted from the French woven-silk industry. According to Col-lins (1962), the use of a squared grid as a basis for design drawing seems to have been familiar to medieval masons and was used in illustra-tions in the 1521 edition of Vitruvius's classic work *De Architectura* (Collins, 1962). Collins noted that the use of the square grid was to be 'of incalculable importance in the subsequent history of architecture since it constituted the origin of what is now termed the "modular" system of design' (Collins, 1962). By the sec-ond half of the twentieth century, squared (or graph) paper was a common drawing surface for artists.

The grid became established firmly in mod-ern European visual art. Mondrian, for exam-ple, working in the early twentieth century, commonly used a composition consisting of a white field with black vertical and horizontal lines (or bars) enclosing rectangular zones of primary colours or white with the suggestion of extension beyond the borders of the can-vas. This suggestion of extension is common in textile and other surface-pattern designs, where a component of the design repeats on a

regular basis in two directions across the plane; in each case, the viewer attempts to identify the repeating unit of the design and seeks an understanding of how this unit repeats vertically and horizontally. Davis noted the use of grids in various forms by artists such as Degas, Gorky, Cézanne, Mondrian and Malevich as well as by Warhol, Vasarely and many others in the twentieth century (Davis, 1972). The work of Mondrian has received particular attention in the educational context. There has, for example, been a focus on the nature of 'artistic' behaviour and the differentiation between this and 'non-artistic' behaviour. Locher, Overbeeke and Stappers (2005) reported on a series of relevant experiments, and an earlier review of the nature of composition (including consideration of the work of Mondrian) was provided by McManus, Cheema and Stoker (1993).

A group of visual-arts-and-design students at the University of Leeds considered the compositional characteristics of the rectangular grid structures typical of the work of the artist Mondrian. Subsequently, the students were requested to construct a rectangle (with black lines on a white background) to dimensions of their choice, to divide this rectangle into at least five smaller rectangles and then to 'colour' each of these with one of three values (black, white or grey). The objective was to create a balanced composition in the tradition of Mondrian. Examples are presented in Figures 5.2–5.11. From this small selection, it is apparent that each student interpreted the word 'balanced' differently, and also that limitless possibilities for visual variation arise even when severe restrictions have been imposed. With this latter

consideration in mind, it should be stressed at this stage that the use of grid forms, guidelines or similar structures by visual artists and designers does not hamper and restrain creative activity but, rather, helps to channel it towards given objectives.

The use of grids became established among surface-pattern designers (e.g. in the design of textiles and wallpaper), particularly as an aid in the precise placing of elements in a regularly repeating design, and among graphic designers in determining the placing of text and images in book or magazine spreads as well as web-page design. Ambrose and Harris (2008) gave a detailed explanation of grid types and their use in a variety of design applications, particularly in promotional and advertising page layouts. They commented: 'A grid is the basic framework with which a design is created. It provides a reference structure that guides the placement of the elements forming the anatomy of a design such as text, images and illustrations, in addition to general elements such as straplines and folios' (Ambrose and Harris, 2008: 27). Key scholarly publications which show the importance of grid systems in design development include Trudeau (1976), Elam (2004), Samara (2005) and Ambrose and Harris (2008). Meanwhile, Nicolai (2009) provided an impressive and useful catalogue of grid types.

grids from rectangles

A range of compositional grids with unit cells based on root rectangles and the golden-section rectangle was proposed previously by

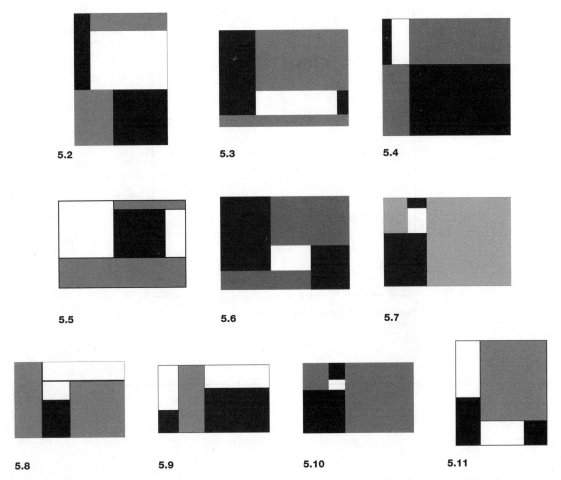

Figure 5.2–5.11 Mondrian-type images. Courtesy of: Yuwei Wang; Claudia Lloyd; Emily Tyson; Fergus Wassell; Matthew Proctor; Maria Trujillo Olaiz; Sian Jones; Selma Quek; Xiaofan Liu; Bethany Mackman.

the present author (Hann, 2012: 46–47, 113). A further grid type, based on plastic-number rectangles (of 1:1.3247) as unit cells, can be proposed also; this is presented in Figure 5.12. Grids based on golden-section (1: 1.6180) rectangular unit cells and root-4 (2:1) rectangular unit cells are presented also in Figures 5.13 and 5.14 respectively; these latter two types have, in the present author's experience, proved to be particularly popular selections as compositional grids among visual-arts-and-design students. The choice of grid type, however, should be at the discretion of the visual artist or designer, and it is not the intention here to suggest that a grid of one variety is in any way superior to others.

Figure 5.12 Compositional grid with plastic-number unit cells (AH).

Figure 5.13 Compositional grid with golden-section unit cells (AH).

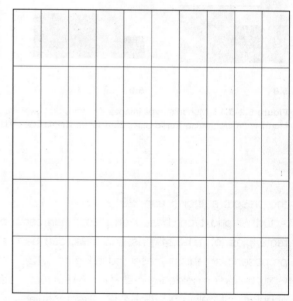

Figure 5.14 Compositional grid with root-4 (2:1) unit cells (AH).

summary

A grid can be defined as a two-dimensional assembly of lines running in at least two distinct directions. It has been seen that grids have been used as frameworks to transfer a drawing from one surface (e.g. a sheet of paper) to a larger-scale surface (e.g. the interior wall of a building); as an indicator of a sequence of actions (e.g. in weaving, to indicate the occasional raising of warp threads); as a compositional and alignment device (e.g. in determining the position of components on either side of a symmetry axis, or to ensure alignment horizontally, vertically or diagonally); or as a measuring device (e.g. scientific graphs or lines of latitude and longitude).

checks and tartans

introduction

Commonly, checks are considered simply as a variety of woven textile, and this is the main consideration in this chapter. Scottish clan tartans famously display a checked feature, using differently coloured yarns in woven-textile form. This chapter explores the nature of checks identifying several types and, in particular, focuses on the characteristics of Scottish clan tartans. A substantial selection of check-type designs, some of unconventional format, is presented also.

definition and classification

Whitney (2010: 1) observed that 'In weaving, the basic structure of woven material relies on [two systems] ... of threads crossing each other in various ways at right angles'. It is this feature of the weaving process which underpins the visual characteristics of all woven checks. In the ICS publication *Weaves, Fabrics, Textile Designing*, a check was defined as 'the effect produced in a fabric by several bands or lines, usually, but not necessarily, of different colors, running in the direction of the warp and crossed at right angles by similar bands running in the ... [weft-ways] direction' (ICS, 1906, section 85: 12).

Often the sequence of colours and the numbers and types of yarns used are the same in both warp and weft directions. Where this is the case, the check may be considered 'balanced' or 'regular', with the component yarns creating square units repeating across and down the fabric (ICS, 1906, section 85: 13). Thus, in balanced checks, lengthways components have ordering, colouring and measured width identical to those used widthways. Meanwhile, an unbalanced check lacks one or more of these attributes. Numerous combinations are possible, and some of these are highlighted in this chapter. A selection of designs based on check-type effects is presented in Figures 6.1–6.12; dated to the early twentieth century, these show the willingness of some designers to step outside the boundaries of conventional right-angled grid forms associated with textiles, whether or not the final design is printed or woven.

Due to the nature of the weaving process itself with yarns running in either a vertical (warp-ways) or a horizontal (weft-ways) direction, it is not surprising that varieties of check have evolved across textile-producing cultures worldwide, as it can be appreciated readily that there will have been the inherent desire among craftspeople for visual variation in the products they produced. The possibility of attaining

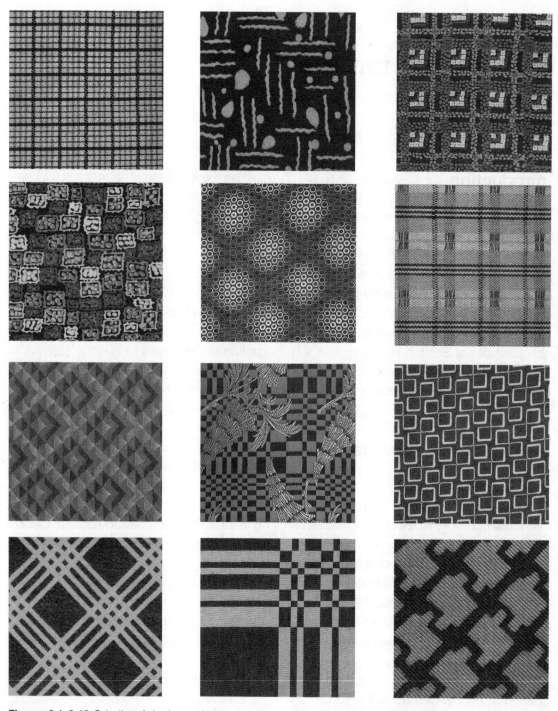

Figures 6.1–6.12 Selection of check-type designs, late nineteenth or early twentieth centuries. Courtesy of ULITA – An Archive of International Textiles, University of Leeds (UK).

such variation by simply adjusting the order of the colours or textures of warp and weft yarns seems to be a straightforward development. The tendency to make this adjustment in a systematic fashion is equally credible as most random variations imposed would make the resultant fabric look unbalanced and not visually resolved. Although not debated fully here, it is readily apparent to the author, on the basis principally of examining numerous cloths produced worldwide, that the numbering and ordering of warp and weft yarns reveal similarities between cultures and time periods. Often it is the case that threads are assembled in numbers which ensure that the breadths of warp-ways and weft-ways stripes are in proportion to one another. Even numbers, such as 2, 4, 8 and 16, appear to predominate, and, assuming that the density of the threads is consistent, this would ensure commensurable proportions in the finished cloth.

In the ICS publication *Weaves, Fabrics, Textile Designing* (ICS, 1906, section 85: 14–20) detailed descriptions were given of check varieties under a range of headings, including 'common two-colour checks', 'common check modifications', 'over checks', 'counterchange checks' and 'shaded checks'; this differentiation and the explanations provided may well be of great value to textile designers, but it is felt that more straightforward means of classification are better suited to this present book. So it is proposed that conventional checks be classified simply as 'balanced' or 'unbalanced'. As indicated above, 'balanced' checks share an equal number of types, colours and varieties of yarn ordered in the same sequence and density in both warp and weft directions, whereas 'unbalanced' checks will not show all of these features. With respect to further classification, it seems appropriate simply to number the sequence of yarn types and colours and their density (e.g. the number per centimetre) in both warp and weft directions.

varieties

Hampshire and Stephenson (2007: 34–63) reviewed the use of squares and checks in heraldry, date plaques, police uniforms and harlequin-type images and as symbols of national identity, as well as the use of tartan and other checked-textile categories including Burberry checks, tattersall checks, hound's tooth checks, shepherd's checks, gingham checks and western plaid. As noted in the previous section, weaving, by its very nature, lends itself to the production of checks by simply varying the colour of threads in warp-ways and weft-ways directions (Hampshire and Stephenson, 2007: 10). Despite the restrictive means of production, woven-textile checks can show immense variation through differences in colouring and numbering of threads. Certain types have attained the status of 'classic' checks in contemporary industrialized societies and have maintained popularity stimulated by globally focused production and distribution. Mention should be made also of the argyle check, a knitted textile which achieved much popularity in the late twentieth and early twenty-first centuries. The characteristics of a selection of textile checks, including the argyle check, are outlined below.

Tartans, which are probably the most famous textile check category, are reviewed later in this

chapter. Varieties of checked textiles have been produced for centuries across most textile-producing nations. By way of example, a small selection of *katagami* (hand-cut paper stencils used in the resist dyeing of a category of traditional Japanese textiles) with check-inspired designs are presented in Figures 6.13–6.21. By the early twenty-first century, wide ranges of industrially produced textiles were manufactured, for example, in West Africa, India and China, and were readily available for Internet purchase. Occasionally, these textiles were in imitation of indigenous, traditional, handcrafted textiles. More often, however, they were in imitation of past European-produced textiles and were available under names such as 'gingham', 'tattersall' and 'hound's tooth' checks, woven-textile varieties which were produced in large quantities a century previously across much of Europe, and especially in Britain. For this reason, these and a few other nineteenth- and twentieth-century check varieties are identified and explained below.

Burberry woven checks are associated closely with the British fashion company of the same name. By the early part of the second decade of the twenty-first century, Burberry checks were world renowned and had gained a substantial following among fashion-conscious rich consumers worldwide; they were also imitated (or forged) extensively. The tattersall woven check consists of thin, regularly spaced, balanced warp and weft stripes, often in two contrasting and alternating colours against a white background; a check effect with repeating square units across the fabric is typical. Named after a famous London auction house specializing in the sale of horses, tattersall fabrics were

used traditionally as horse blankets but, since the early twentieth century, were used increasingly as men's shirting fabrics. The traditional hound's tooth check in woven form is based on a simple twill structure and the use of black and white threads which act to create a fabric with a repeating tessellating (or interlocking) unit in counter-change, black-and-white colouring (Tubbs and Daniels (eds), 1991: 151). Hampshire and Stephenson (2007: 18) noted that the design was particularly popular in the second half of the twentieth century, would appear often in contrasting colours other than black and white and was occasionally printed with repeating units enlarged substantially compared to the traditional woven types. Hampshire and Stephenson (2007: 18) also noted the use of the design, often in enlarged format, outside the realms of clothing fashion, and recognized the appropriateness of the design to end uses involving laser cutting in solid materials such as plywood. A shepherd's check has been defined as a 'small check effect developed in black and white, or in contrasting colours, generally by groups of four, six or eight threads of the two colours and in twill weaves, commonly 2/2 twill' (Tubbs and Daniels (eds), 1991: 278). This description applies probably to the traditional inch-wide check pattern worn at one time by shepherds in the Scottish Borders (Tubbs and Daniels (eds), 1991: 151).

Gingham is a lightweight, plain-woven, checked cotton textile with repeats consisting of the same-sized squares in one colour (often blue, occasionally red) on a white background (Tubbs and Daniels (eds), 1991: 136). The fabric is thus of regular stripes of equal width, of blue (or red) and white, in both warp and weft

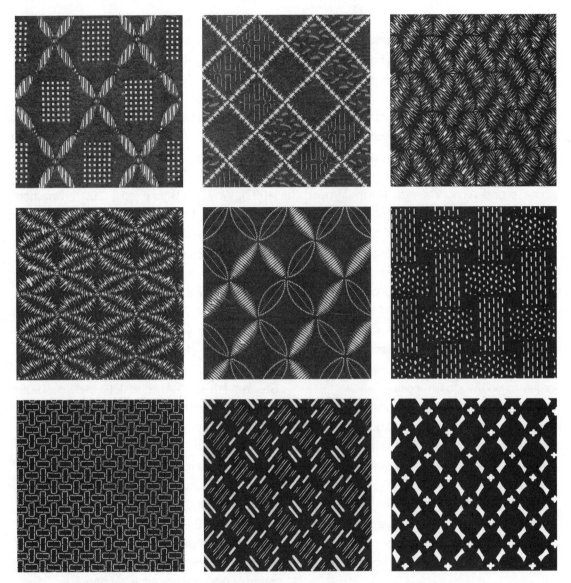

Figures 6.13–6.21 Details from a selection of *katagami*, early twentieth century. Courtesy of ULITA – An Archive of International Textiles, University of Leeds (UK).

directions, in plain weave, producing a solid white square unit with equally sized solid colour units at each corner. Gingham has close associations with various textile-producing regions in both Europe and North America (Hampshire and Stephenson, 2007: 22). Early forms of the fabric were produced in Manchester (England) in the eighteenth century and in the cotton factories of Virginia, Georgia and Alabama (USA) in the late nineteenth century and first half of the twentieth century (Hampshire and Stephenson, 2007: 22). Hampshire and Stephenson

(2007: 26) observed that the even spacing and interlacing of coloured yarns in both warp and weft ensure that the fabric has no 'right' or 'wrong' side in terms of colour. Gingham has been used as curtaining, aprons, pyjamas and bedspreads as well as in many other household textile end uses. The fabric is evocative of European settlers in the western part of North America in the nineteenth century as well as 1950s post–Second-World-War-era North America. Also, in France in the early twentieth century, a version of the fabric was worn as clothing by children (Hampshire and Stephenson, 2007: 22). Checked shirting fabric, occasionally referred to as 'western plaid' (Hampshire and Stephenson, 2007: 28), which evolved from simple cotton work wear used by North American and Mexican ranch workers, has been associated popularly with the Wild West (a popularity that is due largely to Hollywood film costume).

Argyle checks have diamond-shaped unit cells and, as mentioned previously, are knitted rather than woven. By the late twentieth century, argyle-checked knitwear had developed a countryside and golfing attire image, and was associated closely with Scottish knitwear producers such as Pringle, and Lyle and Scott.

Scottish clan tartans

The clan tartans of Scotland are probably the best known (and most complex) of all checked-textile categories. Numerous specialist publications, dealing with the identification of tartan types and their relationship with the families, clans and districts of Scotland, have

appeared since the mid-nineteenth century. Often, contemporary paintings, with subjects wearing check-type fabrics, are cited as evidence for the use of tartan in the eighteenth and nineteenth centuries. Among the most readily accessible publications are Bain (1938), McClintock (1943), Innes (1945), Hesketh (1961), Dunbar (1962), Scarlett (1972, 1973), Stewart (1974), Dunbar (1984), Teall and Smith (1992), Way and Squire (eds) (2000), Urquhart (2000, 2005), Martine (2008) and Zaczek and Phillips (2009). Various tartan guide maps (with illustrations of tartan types and identification of geographical locations) have been produced over the years; a relatively recent example is the *Tartan Map of Scotland* (Collins, 2012). Some of the rarer books, such as Logan (1831), Stuart and Stuart (1845), Smith and Smith (1850), Smibert (1850), Grant (1886), Whyte (1891), Stewart (1893), Whyte (1906), Adam (1908) and MacKay (1924), are available for reference at relevant specialist libraries. An authoritative background review of clan history and an account of the role of tartan as a component of highland dress were provided respectively by MacInnes (2000) and Campbell (2000). Stewart (1974: 113–117) gave an annotated bibliography of the more important publications (published between 1831 and 1973), including many of the rarer books listed above.

The word 'tartan' implies a cloth of wool, but similar colourings, in silk and fine cottons, have been common since the early twentieth century (ICS, 1906: 24). Grossman and Boykin (1988: 1) explained that a tartan was 'based on the regular interweaving of warp and weft stripes to form repeated pattern blocks or squares … Thus, the tartan is an inherently regular, balanced

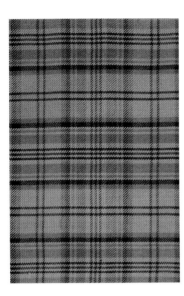

Plate 1a Balmoral: A nineteenth-century design associated with the British royal family, described in some detail by D. W. Stewart (1893: XLV). The cloth sett was given by D. C. Stewart (1974: 38).

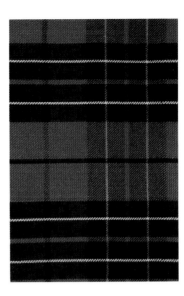

Plate 1b Brodie: D. W. Stewart (1893: III) maintained that the design depicted was of 'some antiquity, since many of the oldest tartans are variations of the red and black check, popularly styled Rob Roy, with the addition of narrow lines of various hues'. The cloth sett was given by D. C. Stewart (1974: 40).

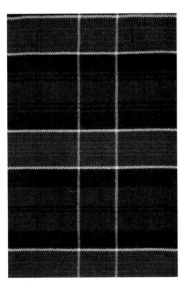

Plate 1c Campbell of Breadalbane: The design shown here was reproduced from a portrait dated to between the late eighteenth and early nineteenth centuries, and has been found in early collections apparently 'dating from 1790 down to 1840' (D.W. Stewart, 1893: IV). Full sett details and further descriptions of various Campbell tartans were given by D. C. Stewart (1974: 43–44). Short descriptive details were provided by Zaczek and Phillips (2004: 136–137).

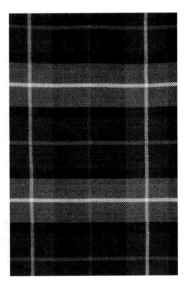

Plate 1d Davidson: At least two designs are associated with this name. The one presented here is, according to D. W. Stewart (1893: V), the earlier. A brief description, together with the relevant cloth sett, was given by D. C. Stewart (1974: 49). Short descriptive details were provided also by Zaczek and Phillips (2004: 187).

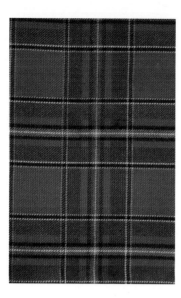

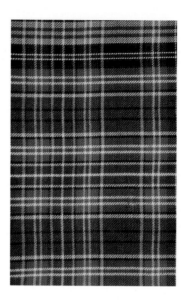

Plate 2a Drummond of Perth: According to D. W. Stewart (1893: VI), this tartan design was held in early collections, suggesting its antiquity. A similar design is claimed by other families, including the Grants (Stewart, 1893: VI). A full description of this and related designs, together with relevant cloth setts, was provided by D. C. Stewart (1974: 50–51). Brief historical details of the Drummond family were provided by Zaczek and Phillips (2004: 187).

Plate 2b Drummond of Strathallan: According to D. W. Stewart (1893: VII), the design shown was of an 'early date' and in the early nineteenth century was associated also with the Ogilvie family. A cloth sett was provided by D. C. Stewart (1974: 51).

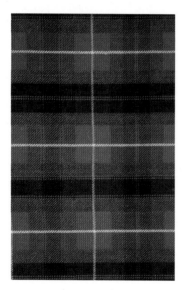

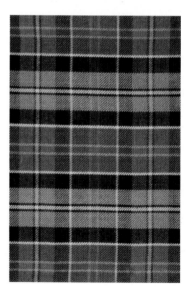

Plate 2c Fraser of Lovat: According to D. W. Stewart (1893: IX), various family portraits confirm that this design, with minor modifications, was used by Clan Fraser. Various setts for Fraser tartans were given by D. C. Stewart (1974: 54–55).

Plate 2d From a coat worn at the Battle of Culloden: D. W. Stewart (1893: XLIII) noted that the design was reproduced from a riding or military coat. The cloth has a complex sett (given by D. C. Stewart, 1974: 110).

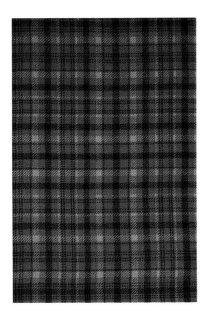

Plate 3a From a cloth fragment found at Culloden battlefield: D. W. Stewart believed that the design was of 'great age' and produced in the early eighteenth century, 'if not considerably earlier' (1893: XLIV). Full details, including the relevant sett, were provided by D. C. Stewart (1974: 107–109).

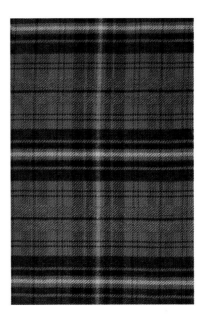

Plate 3b From cloth worn by Prince Charles Edward at Holyrood Palace: According to D. W. Stewart (1893: XLI), this design was worn by Prince Charles Edward during a brief visit to Edinburgh in 1745. The cloth sett was provided by D. C. Stewart (1974: 110).

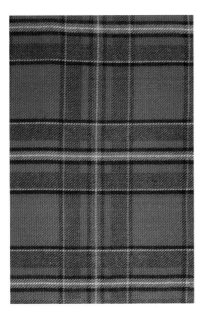

Plate 3c From Prince Charles Edward's cloak (at Fingask): D. W. Stewart (1893: XL) noted that the design was similar to the tartan of the Drummonds of Perth (depicted here in Plate 2a).

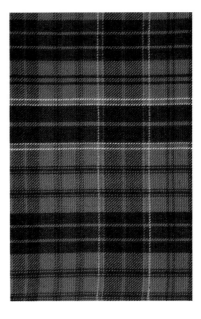

Plate 3d Huntley: The design depicted here is sometimes designated 'Huntley and Brodie' according to D. W. Stewart (1893: XI) and has been associated also with the Gordon and Fraser families. The cloth sett was given by D. C. Stewart (1974: 59–60), who noted also the striking similarity between this design and the cloth named the 'Prince's Own' tartan (Plate 7d).

Plate 4a Kennedy: According to D. W. Stewart (1893: XIII), the design became widely adopted among Kennedy families as an 'emblem of their Jacobite sympathies'. Further explanation and the relevant sett were given by D. C. Stewart (1974: 62–63). Short descriptive details were provided by Zaczek and Phillips (2004: 154–155).

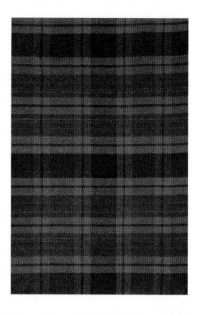

Plate 4b Logan: According to D. W. Stewart (1893: XIV), this is a design held in many early collections, though various designs have been associated with the same name. D. C. Stewart gave alternative setts and noted also that the design was associated with the name of Rose (1974: 65). Short descriptive details were provided by Zaczek and Phillips (2004: 201).

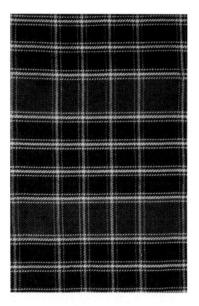

Plate 4c Lord of the Isles (hunting): This design is based on that depicted in a late eighteenth-century painting (D. W. Stewart, 1893: I).

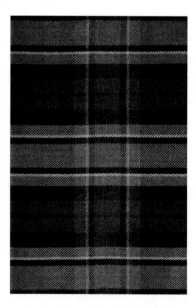

Plate 4d MacCallum: D. C. Stewart (1974: 69) noted that three tartan designs have been associated with the name MacCallum; the one depicted here, and also in D. W. Stewart (1893: XV), is probably the most ancient. Alternative cloth setts were presented by D. C. Stewart (1974: 68–69), and short descriptive details were provided by Zaczek and Phillips (2004: 204).

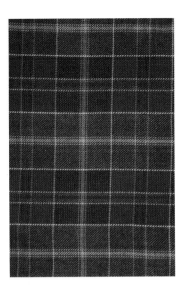

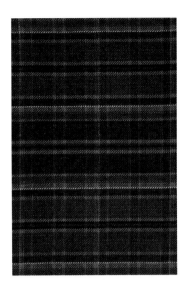

Plate 5a MacDonald: Numerous cloth setts are associated with the name MacDonald (D. C. Stewart, 1974: 70–73). According to D. W. Stewart, the design depicted here dates back to the mid-nineteenth century (1893: XVI). Short descriptive details were provided by Zaczek and Phillips (2004: 156–157).

Plate 5b MacIntyre and Glenorchy: According to D. W. Stewart (1893: XIX), this design is generally associated with both names but occasionally with Glenorchy only. The design was reproduced in Edinburgh around 1820 from fragments of 'ancient origin' (D. W. Stewart, 1893: XIX). Brief historical details and the cloth sett were given by D. C. Stewart (1974: 77).

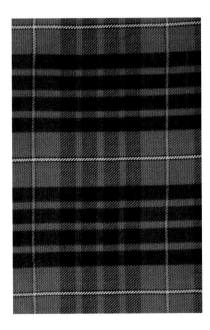

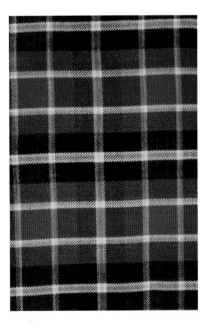

Plate 5c MacKeane (or MacIan): According to D. W. Stewart (1893: XXII), the design depicted here was described in various nineteenth-century manuscripts. Various versions of the name have appeared over the years (including McIan, MacCoin and M'Kane). The cloth sett was given by D. C. Stewart (1974: 78).

Plate 5d MacLachlan: According to D. W. Stewart (1893: XX), the design depicted here is one of two associated with the same name. Alternative cloth setts were given by D. C. Stewart (1974: 81), and short descriptive details were provided by Zaczek and Phillips (2004: 211).

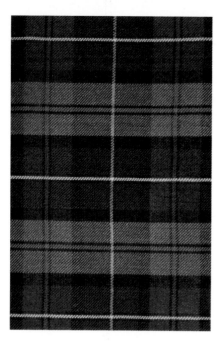

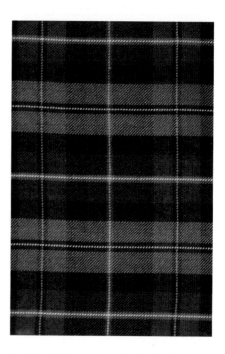

Plate 6a MacLeod: D. W. Stewart (1893: XXIV) noted various views on the identity of the tartan most closely associated with MacLeod. The design presented here is probably the earliest and the most common. Alternative cloth setts were given by D. C. Stewart (1974: 83–84), and short descriptive details were provided by Zaczek and Phillips (2004: 164–165).

Plate 6b MacNeill (sometimes MacNeil): D. W. Stewart noted that this design was held in many early collections and also that 'several branches of the clan have other designs' (1893: XXV). D. C. Stewart gave five cloth setts (1974: 85–86), and short descriptive details were provided by Zaczek and Phillips (2004: 214–215).

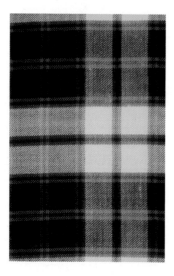

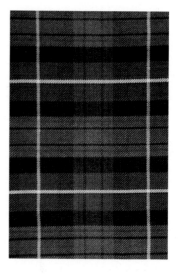

Plate 6c MacPherson: D. W. Stewart (1893: XXVI) noted that there are a 'multiplicity of setts' of MacPherson tartans. D. C. Stewart gave further details and five cloth setts (1974: 87–88). Short descriptive details were provided by Zaczek and Phillips (2004: 215).

Plate 6d MacRae: According to D. W. Stewart, the design shown here was reproduced from a kilt, 'believed to have been worn by a member of Clan MacRae … in 1715' (1893: XXVII). There appear to be several varieties, and four cloth setts were given by D. C. Stewart (1974: 89–90). Short descriptive details were provided by Zaczek and Phillips (2004: 216).

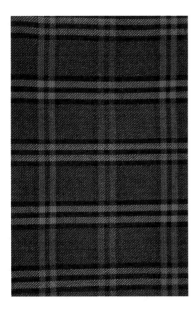

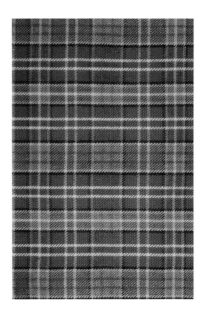

Plate 7a Montgomerie (sometimes Montgomery): The design depicted was, according to D. W. Stewart, 'adopted by the Montgomeries of Ayrshire' in the early eighteenth century (1893: XXIX). Alternative cloth setts were provided by D. C. Stewart (1974: 92).

Plate 7b Ogilvie (sometimes Ogilvy): D. W. Stewart noted that the Ogilvies adopted the Drummond of Strathallan (see Plate 2b) tartan design after the families became connected through marriage in 1812 (1893: XXX). The illustration presented here is of a design which predates this connection. Alternative setts were given by D. C. Stewart (1974: 95–96). Short descriptive details were provided by Zaczek and Phillips (2004: 224).

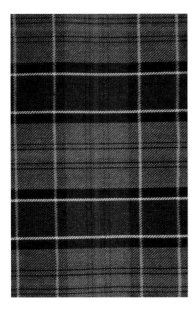

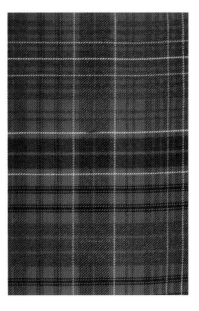

Plate 7c Ogilvie (hunting): D. W. Stewart noted that this design was held in various early nineteenth-century collections (1893: XXXI). The relevant cloth sett was given by D. C. Stewart (1974: 95).

Plate 7d Prince's Own: Associated with Prince Charles Edward, this design is ranked by D. W. Stewart as 'amongst the earliest' (1893: XLII).

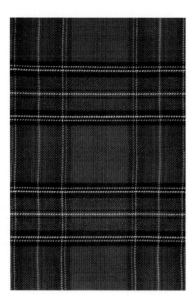

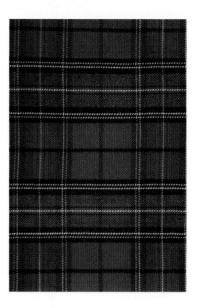

Plate 8a Stewart of Appin: D. W. Stewart observed that this design has close similarities with the Stewart of Atholl and Royal Stewart tartans (1893: XXXIV). The relevant cloth setts for this and other Stewart tartans were given by D. C. Stewart (1974: 102–104).

Plate 8b Stewart of Galloway: D. W. Stewart described this simply as 'a family tartan', differing only slightly from the Stewart of Appin (1893: XXXVI).

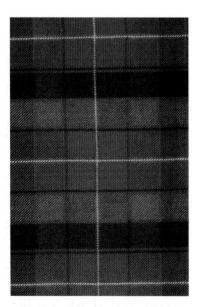

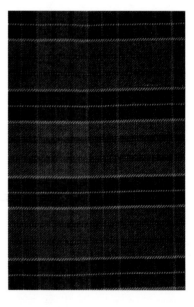

Plate 8c Robertson: Regarded by D. W. Stewart as a relatively early design, dating, at least, back to the late eighteenth century (1893: XXXII). Further details together with three cloth setts were given by D. C. Stewart (1974: 97). Short descriptive details were provided by Zaczek and Phillips (2004: 168–169).

Plate 8d Stewart: There are numerous varieties of Stewart tartan. Further details, together with the numbering for eleven cloth setts, were provided by D. C. Stewart (1974: 102–104). According to D. W. Stewart, the design given here was in use at least since 1745, and known as 'Old Stewart' (1893: XXXIII). Short descriptive details were provided by Zaczek and Phillips (2004: 172–173).

weave based on repetition of square pattern blocks'. These square pattern blocks overlap, and the dimension of each is determined by the 'sett' or numbering and colouring of threads in the lengthways and widthways directions. As indicated in the previous section, there are numerous publications which assist with the identification of tartan types. However, there appear to be only a few publications which give a focus on actual production issues, including the precise order of differently coloured yarns. Stewart's (1974) publication stands out as one of these few and presents details of the setts (or order of threads) across over 250 designs, though he observed that 'no list could pretend to be exhaustive' (Stewart, 1974: 31).

The sett of a tartan thus gives the ordering of the threads, including the planned colour order and number of warp threads and weft threads per unit length (inch or centimetre). Most tartan fabrics are of square sett, with identical ordering and colouring of yarns in both warp and weft directions, but, as noted by Stewart (1974: 33–34), in practice the weaver would modify the sett by adjusting the numbers, colours and types of yarns used, either to accommodate production circumstances or possibly to take account of economy and the ready availability of particular yarns; as a result, the numbers of yarns in warp and weft directions may have been adjusted and may have resulted, occasionally, in a non-square sett. Urquhart (2000: 14) noted that setts were either 'symmetrical' or 'asymmetrical'. Symmetrical setts 'contain two pivots – the points where the sequence of stripes, starting at the pivot, can be seen to be identical in four directions: north, south [or warp-ways], east and west [weft-ways]. The full

sett is the sequence of colours read from right to left, turned about the pivot, and repeated left to right' (Urquhart, 2000: 14). Pivot points thus act as points of reflection symmetry. Asymmetrical setts, on the other hand, 'have no true pivots … The pattern is repeated from right to left across the width of the cloth' (Urquhart, 2000: 14). Examples of asymmetrical setts include the Buchanan and MacAlpine tartans (Stewart, 1974: 41, 66). The majority of setts are, however, symmetrical, and these appear largely the same when viewed across the cloth (horizontally, from right to left or left to right) and down the length of the cloth (vertically, from top to bottom or bottom to top); the direction of the twill lines will be different, however, depending on whether they are viewed horizontally or vertically, but in most cases this is only detectable at a close range of less than twenty centimetres and in some cases only at closer range with the assistance of magnification of the constituent woven structure.

Although, as a class of textile, tartans evoke thoughts of very ancient lineage, their detailed classification is in fact of more recent origin. When woven (using a twill weave), they involve similar colouring plans in warp- and weft-ways directions. Thus, many tartans have square repeating units. There are references to tartans in many historical documents, paintings and illustrations. Hampshire and Stephenson (2007: 39) noted a German woodcut dated as early as 1631 showing Scottish highland soldiers wearing tartan kilts. Bonnie Prince Charlie's armies were organized into tartan-clad regiments. After the Jacobite defeat at the Battle of Culloden (in 1746), a range of repressive legislation was enacted by the English authorities; amongst

much else, this included banning of highland dress (MacInnes, 2000: 18; Hampshire and Stephenson, 2007: 39).

There was a substantial increase in the popularity of tartans among the general public in the wake of early visits by Queen Victoria to Scotland in the mid-nineteenth century, a trend that continued throughout much of the twentieth century with bespoke tartans commissioned by major multinational companies, and tartans of various kinds being presented by eminent fashion designers in various catwalk fashion shows. Examples of the colourings and yarn numbers required for numerous tartans have been highlighted in past publications (e.g. ICS, 1906: section 85: 24–26; Stewart, 1974: 31–111). In all cases, the colouring extends over a surprisingly large number of threads. Examples include the Royal Stuart (184 threads), Gordon (418 threads), Black Watch (184 threads), MacGowan (292 threads), MacPherson (182 threads) and Campbell of Breadalbane (244 threads) (ICS: section 85: 25–26). Campbell of Argyll requires 164 threads for each component repeat (in both warp and weft directions); the colouring has been listed as follows: 26 dark green, 2 black, 4 yellow, 2 black, 26 dark green, 26 black, 24 dark blue, 4 white, 24 dark blue and 26 black (ICS, 1906: section 85: 24). The following contractions/abbreviations are in common usage among weavers to express the sequence of colours used in traditional tartans: 'Bk (Black); B (Dark Blue); P (Purple); LB or AZ (Light Blue, Azure); G (Dark Green); LG (Light Green); R (Scarlet); Cr (Crimson); Y (yellow); W (White); Gy (Grey). Other colours are named' (Stewart, 1974: 33).

An important consideration is the underlying weave; this is invariably a twill weave, which produces a cloth with diagonal lines on the surface (Tubbs and Daniels (eds) 1991: 329). The orientation of these diagonal (or twill) lines on the face of the cloth runs from the bottom left to upper right, or is in a 'Z' direction (i.e. where the twill lines of the cloth are oriented in the same direction as the middle bar of the letter 'Z') (Urquhart, 2000: 14). It should be noted also that, where repairs to warp or weft have been made, all associated knots are pulled to the back of the manufactured cloth. It is remarkable, when reviewing the order and numbers of coloured threads in the 258 setts presented by Stewart (1974: 37–111), that all numbers presented are even numbers, with a seeming predominance of numbers 2, 4, 6, 8, 16, 24 and 32. As mentioned previously (in the second section of this chapter), this predominance of groups of threads in even numbers, in checked textiles of various kinds, allows the weaver to ensure commensurable stripe widths in warp and weft directions. Assuming a square sett, the resultant dimensions of the overlapping squares in the finished cloth will be commensurable with each other. Commensurable, overlapping squares are therefore a feature across the majority of tartan types.

Campbell (2000: 34) remarked that 'There is no strict law which lays down the shade of colour to be employed, unless a sett specifically contains a lighter and darker form of the same colour ... one manufacturer's "light blue" may in fact be darker than another's "dark blue". Red is red and green is green, whatever kind of red or green it is and many variations may be found'. Variations of colour will occur also through employing different dye types. Early dyes, mainly from vegetable sources, were not as light fast as modern synthetic dyes (which

on the whole produce much stronger colours with greater light fastness). The present author has noticed a surprisingly wide variation in the shades and orders of colours given in the illustrations of various tartan types in different publications. For this reason, the tartans selected as colour plates in this present book have been reproduced (with minor editorial amendments) from cloth samples contained in Stewart's (1893) publication *Old and Rare Scottish Tartans*, and cross-referenced by other authoritative sources held at the University of Leeds (UK).

As observed by Campbell (2000: 34), 'In addition to the normal clan tartan, in some cases a clan may also have "Hunting" or "Dress" setts. The former is in less violent colours to act as better camouflage while out on the hill, the latter designed specifically for show, often in a pattern which contains a lot of white'. Across the various reference books, several varieties can be found, including hunting tartans, dress tartans, district tartans, clan and family tartans, regimental tartans, chief's tartans, royal tartans, mourning tartans and corporate tartans; many of these are of relatively recent late nineteenth- or twentieth-century origin.

summary

Checks are found most commonly in woven textiles, with coloured groups of yarns repeating systematically in warp and weft directions. Often checks are regarded as 'balanced', with equally spaced numbers, types and colours of yarns in both warp and weft directions; the term 'square sett' is used occasionally rather than 'balanced'. Where widthways components, their colours and their ordering are identical to those used lengthways in a check, then the descriptive classification in length- and widthways directions should be simply stated as the same. A typical feature is a repeating square unit across the fabric's surface. Various categories of check can be identified worldwide, many produced traditionally using hand-spinning and hand-weaving techniques. Industrially produced woven checks include tattersall checks, hound's tooth checks, shepherd's checks, gingham checks and Burberry checks. Argyle checks have a diamond-shaped repeating unit in knitted rather than woven form. Tartans constitute the best-known (and probably also the most complex) variety of woven checks; a classification system and detailed instructions for production of the various types have evolved since the mid-nineteenth century. Based on consideration of the samples provided in D. W. Stewart (1893) and the setts provided by D. C. Stewart (1974), it is apparent to the present author that the majority of tartan designs display overlapping squares which are clearly commensurable with each other. It is proposed that checks be classified first as simply balanced or unbalanced, with balanced checks sharing an equal number of types, colours and varieties of yarns in the same sequence and density in both warp and weft directions, to produce a square repeating unit, whereas unbalanced checks will not show these features. Further to this, it seems appropriate simply to number the colours and types of yarns and their sequence in both (warp- and weft-ways) directions, as is the practice when making specific reference to tartan setts. A selection of check designs, produced by visual-arts-and-design students at the University of Leeds, is presented in Figures 6.22–6.117.

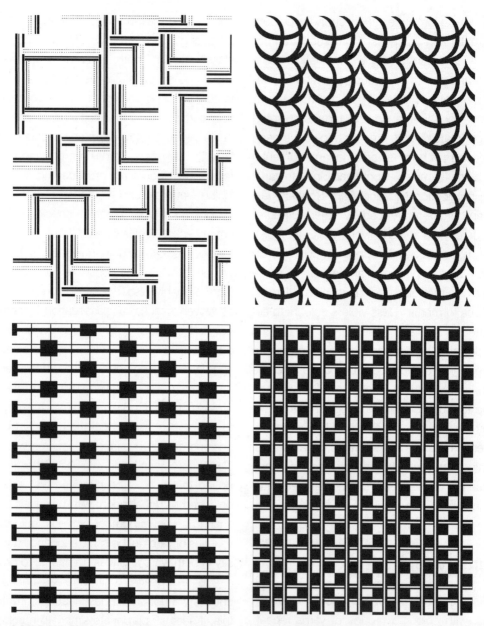

Figures 6.22–6.117 Check designs, 2014. Courtesy of: Obafunbi Adebekun, Rosanna Adkins, Yasmeen Alfaify, Chaorlotte Allen, Olivia Bambrough, Hannah Brook, Lisa Byers, Zoe Blair, Mary Bowkett, Natalie Cahill, Alice Collins, Emily Clarke, Sarah Conn, Amber Druce, Clare Darby, Freya Dick-Cleland, Hazel Fletcher, Isabel Fletcher, Danice Gilmore, Sophie Harper, Bryony Hatrick, Imogen Henderson, Katrina Holmes, Victoria Hughes, Paula Jankowska, Bronte Jeffrey-Mann, Sophie Johnson, Sian Jones, Tayla Keir, Pamela Lee, Deniche Benevides Leoncio I, Xiaofan Liu, Emilia Livingston, Claudia Lloyd, Bethany Mackman, Ellen McLoughlin, Harriet Muddiman, Kayleigh Naysmith, William Nichols, Thabata Oliveira, Megan Peirson-Shaw, Matthew Proctor, Katie Reynolds, Sebastian Scott, Maria Trujillo Olaiz, Emily Tyson, Aleksandar Velikov, Samantha Walsh, Fergus Wassell, Emma Webb, Erika Wilson, Rachel Young and Pawel Znojek.

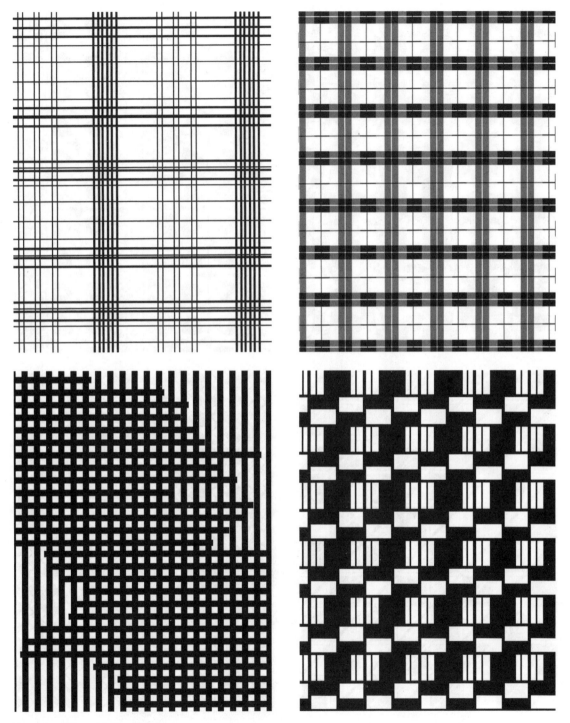

Figures 6.22–6.117 (continued)

Figures 6.22–6.117 (*continued*)

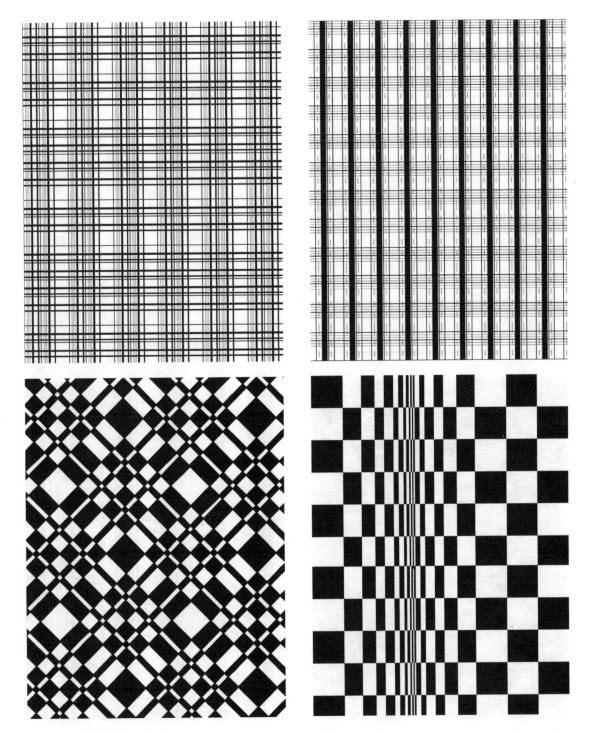

Figures 6.22–6.117 (*continued*)

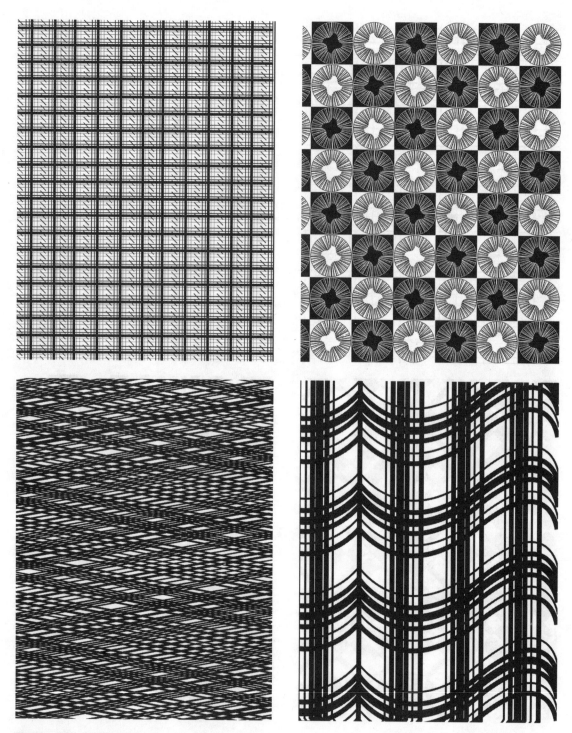

Figures 6.22–6.117 (continued)

Figures 6.22–6.117 (*continued*)

Figures 6.22–6.117 (continued)

Figures 6.22–6.117 (*continued*)

Figures 6.22–6.117 (*continued*)

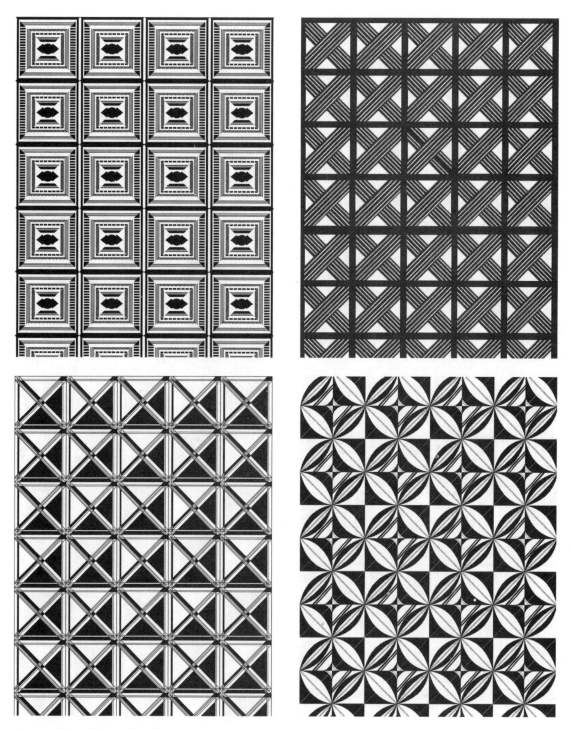

Figures 6.22–6.117 *(continued)*

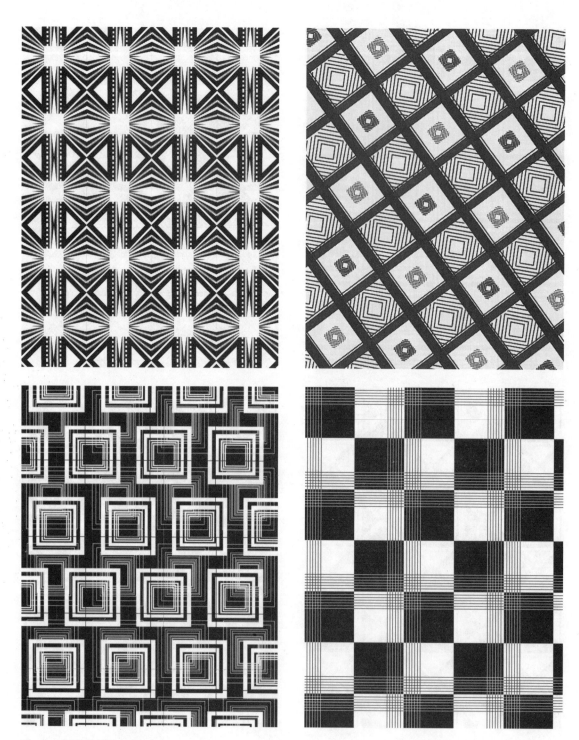

Figures 6.22–6.117 (*continued*)

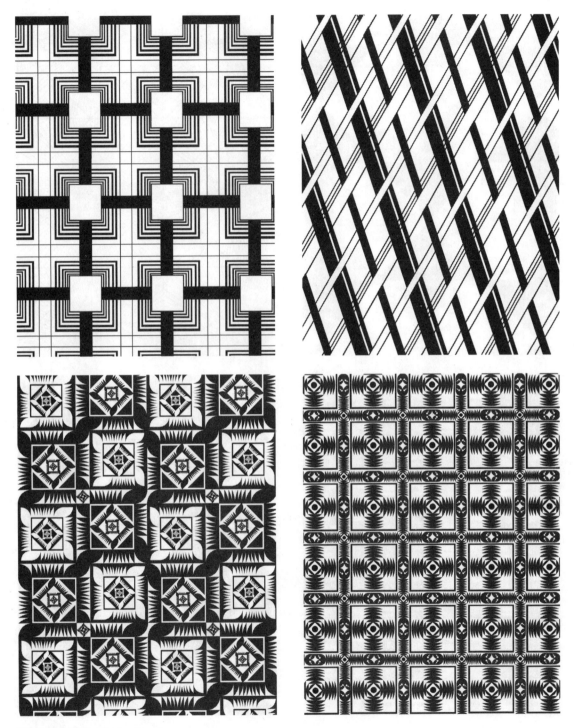

Figures 6.22–6.117 (*continued*)

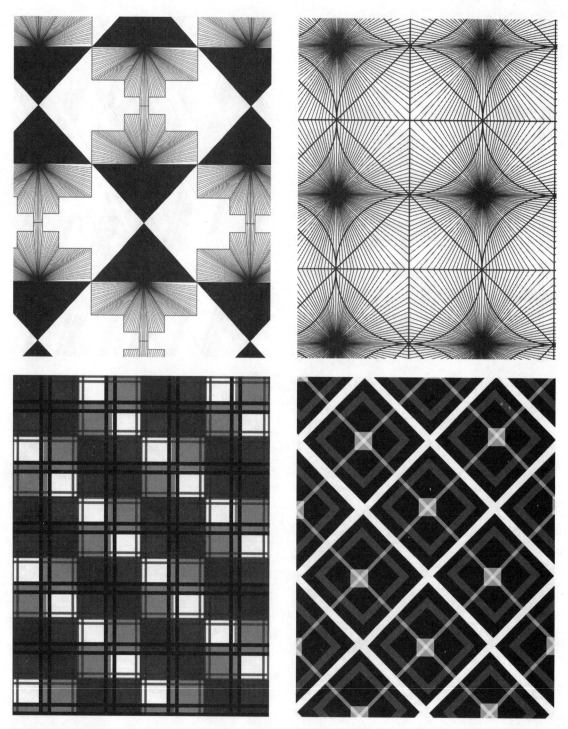

Figures 6.22–6.117 (continued)

Figures 6.22–6.117 (*continued*)

Figures 6.22–6.117 (continued)

Figures 6.22–6.117 (*continued*)

Figures 6.22–6.117 (*continued*)

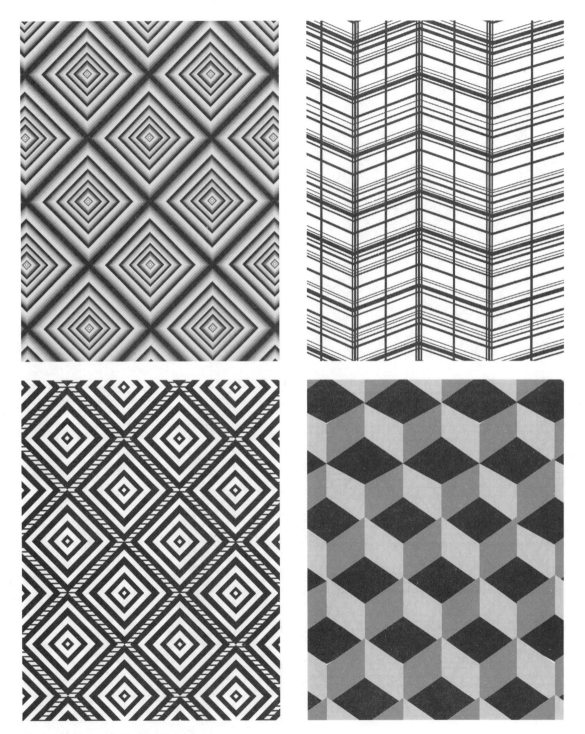

Figures 6.22–6.117 (*continued*)

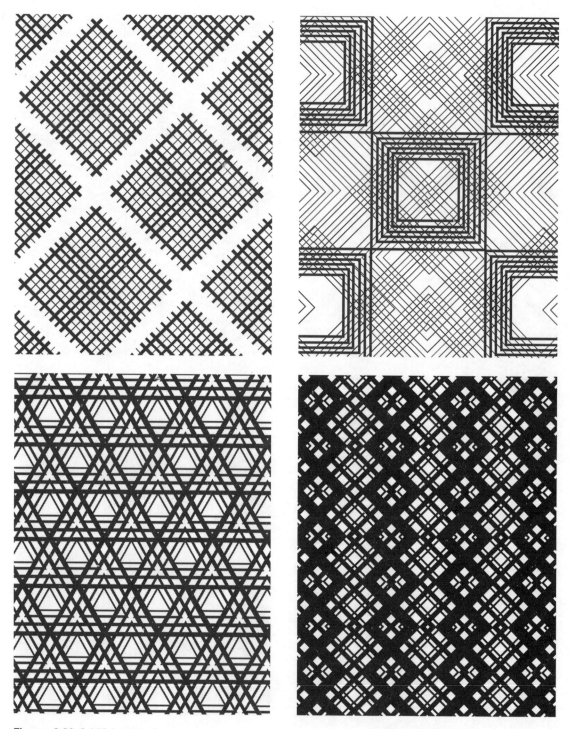

Figures 6.22–6.117 (*continued*)

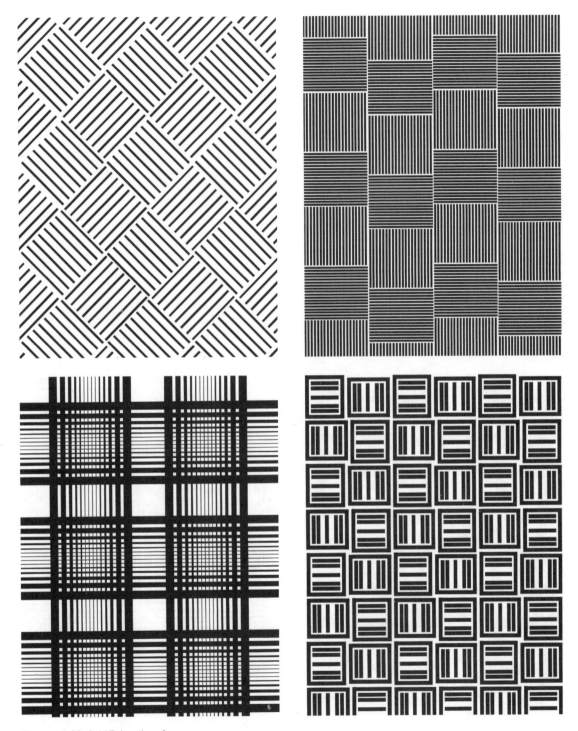

Figures 6.22–6.117 (*continued*)

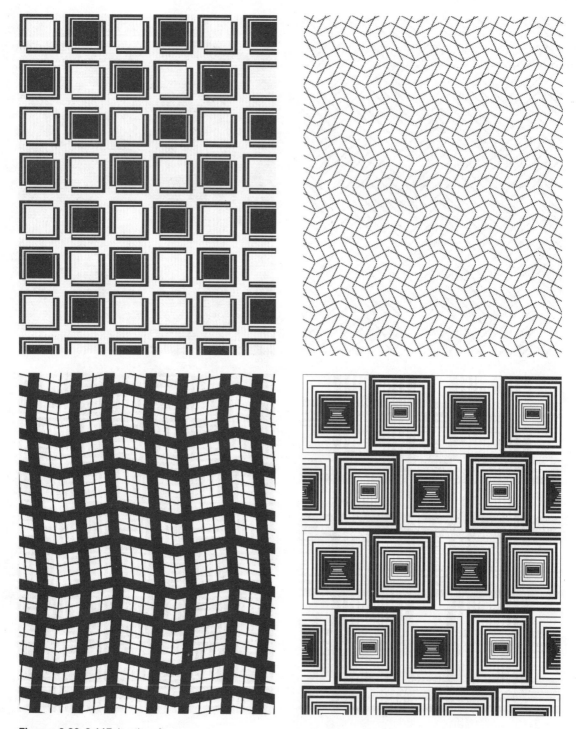

Figures 6.22–6.117 (*continued*)

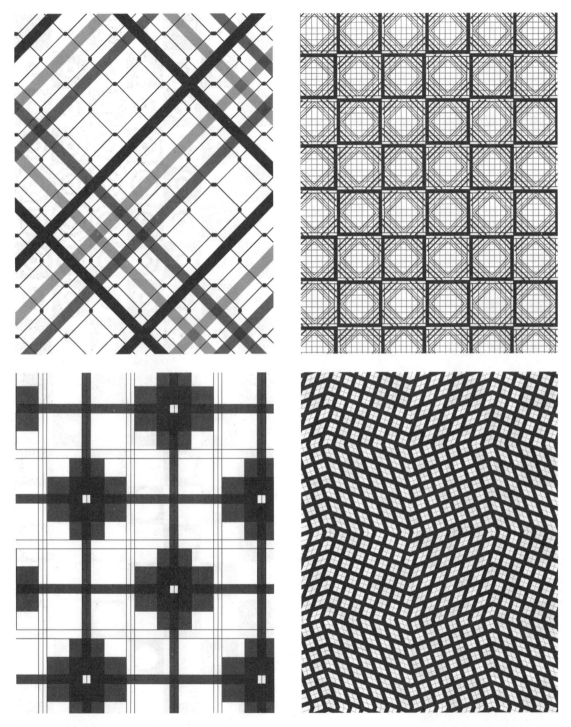

Figures 6.22–6.117 (*continued*)

Figures 6.22–6.117 (continued)

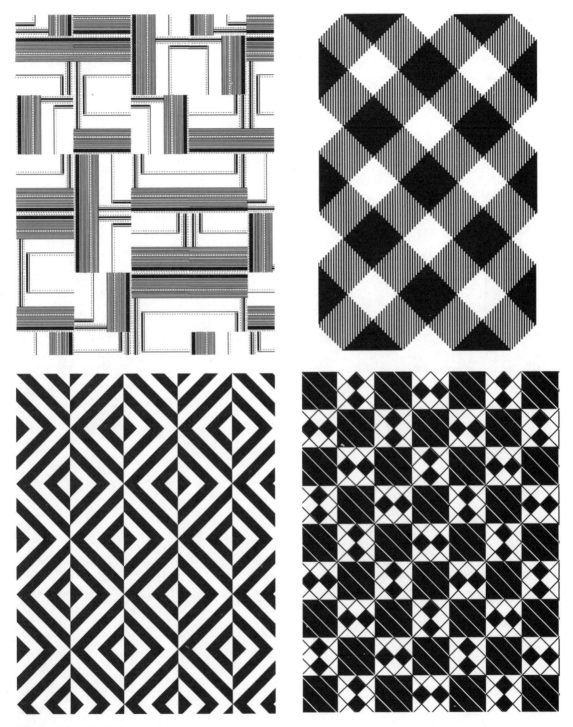

Figures 6.22–6.117 (continued)

planned divisions of space

introduction

This chapter proposes varieties of grid, adapted from classes of tiling structures (or tilings) identified previously by the present author (Hann, 2012: 51–57). These tiling structures offer visually resolved frameworks combining known varieties of polygon and covering the two-dimensional plane without gap or overlap. As such, they appear to be suited as compositional frameworks for use by visual-arts-and-design practitioners working in two dimensions. Drawings of grids, compared to drawings of tilings, have a different intention and potential application. Grids are used largely as guidelines or frameworks by visual artists and designers to inform compositional decisions. In this context, it appears that structures used have been restricted largely to the three 'regular' grids (consisting of equilateral triangles, squares or hexagons). This chapter introduces the practitioner to an array of further compositional frameworks constituted by grids underlying various well-known tiling arrangements.

By way of introduction, it is worth remarking that, although the author does not consider the terms 'regular', 'semi-regular' and 'demi-regular' to be adequate descriptors of three of the classes of grid proposed below, this terminology has been adopted from that accepted widely in tiling classification; proposing new unfamiliar terminology would not assist understanding.

regular and semi-regular divisions

As noted above, regular grids are of three types (Figures 7.1–7.3), each with equally sized unit cells of one particular type of regular polygon (equilateral triangle, square or hexagon). Further classes of grid, based on well-known groups of tilings, can be proposed. A class of grid, which will be referred to here as 'semi-regular grids', is illustrated in Figures 7.4–7.11.

demi-regular divisions

A class of twenty grids, suggested by the group of demi-regular tilings, is presented in Figures 7.12–7.31.

non-edge-to-edge divisions

The component unit cells of the grid types considered so far in this chapter are of regular polygonal shape, with each side of equal length. Like their tiling equivalents, they

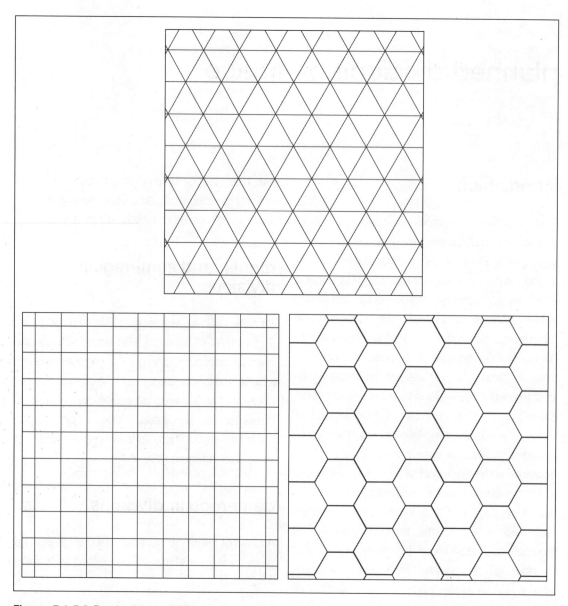

Figures 7.1–7.3 Regular divisions (JSS).

tessellate edge to edge, with the result that each unit cell shares each side with one adjacent unit cell only. A sub-category of grids can be suggested: those with unit cells which do not tessellate edge to edge in the same way and, in some cases, may not use regular polygons as unit cells. Examples are given in Figures 7.32–7.34. The non-edge-to-edge tiling equivalents were described previously by the present author (Hann, 2012: 50–51).

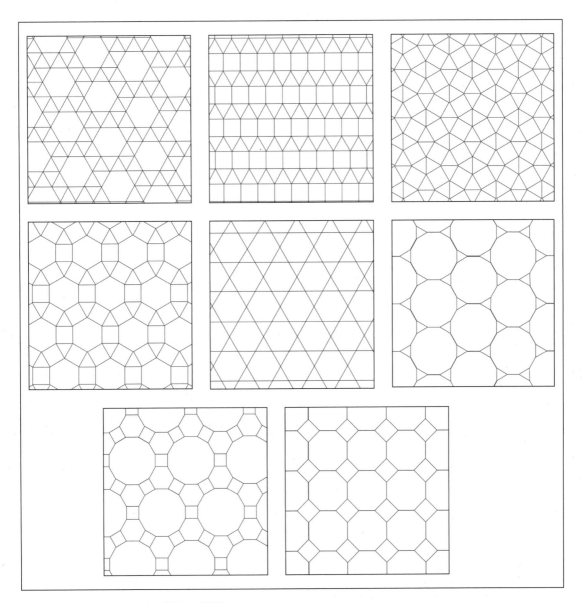

Figure 7.4–7.11 Semi-regular divisions (JSS).

aperiodic divisions

The regular, semi-regular, demi-regular and non-edge-to-edge grids introduced in the sections above are 'periodic' in nature (that is, they display regular repetition of all component parts across the plane). Another category of grids can be suggested. Shown here in Figure 7.35 is an aperiodic grid adapted from a well-known aperiodic tiling arrangement associated with Roger Penrose (Hann, 2012: 57). This grid consists of two distinct polygons,

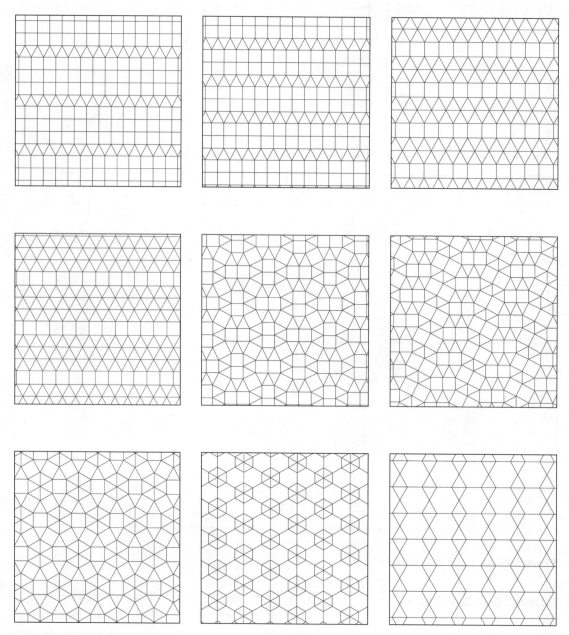

Figures 7.12–7.31 Demi-regular divisions (AH).

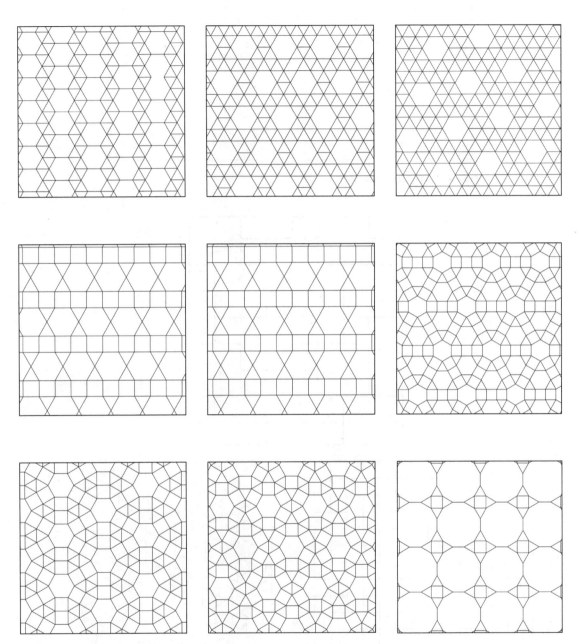

Figures 7.12–7.31 (continued)

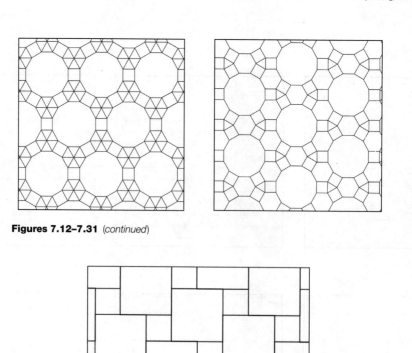

Figures 7.12–7.31 (*continued*)

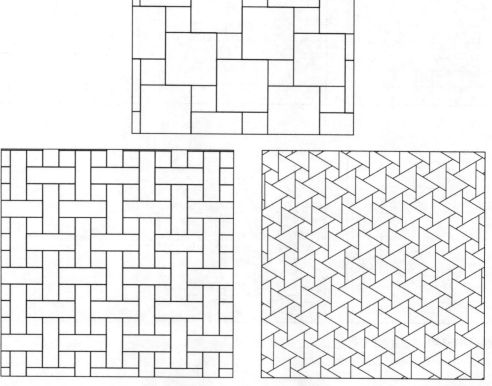

Figures 7.32–7.34 Non-edge-to-edge divisions (JSS).

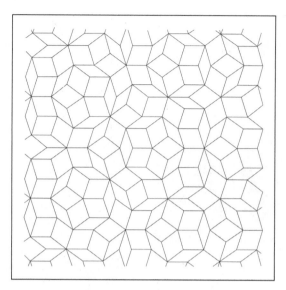

Figures 7.35 Aperiodic division (JSS).

one with interior angles of 144 degrees, 144 degrees, 36 degrees and 36 degrees, and the other with interior angles of 72 degrees, 72 degrees, 108 degrees and 108 degrees. Local points of fivefold rotation and lines of bilateral reflection symmetry are exhibited, yet this grid does not show strict repetition across the plane (i.e. it is aperiodic).

summary

Various grid classes, adapted from known varieties of tiling, are proposed in this chapter. Regular grids consist of arrangements of squares, equilateral triangles or hexagons, and semi-regular and demi-regular grids consist of arrangements of more than one type of regular-polygon unit cell; in each of the three cases, constituent unit cells share sides with each adjacent unit cell. With non-edge-to-edge grids, each unit cell has non-matching sides:

that is, constituent unit cells either have sides shared with more than one adjacent unit cell or may only share part of the side of an adjacent unit cell. In each of these four cases, regular repetition of unit cells (or groups of unit cells) is a feature (i.e. each of these grid classes is periodic). An aperiodic grid arrangement was proposed also, consisting of two distinct polygon unit cells; such an arrangement shows interesting local symmetries yet does not enter into formal repetition. In each case, across all the grids proposed, fully tessellating arrangements are evident (i.e. component unit cells cover the plane without gap or overlap). It is proposed that all of these grid types be considered for use as compositional grids, either as templates for organizing visual components or as frameworks to build periodic as well as aperiodic designs. By way of example, Figures 7.36–7.41 present a small selection of compositional grids, each with the addition of a moiré (or interference) effect.

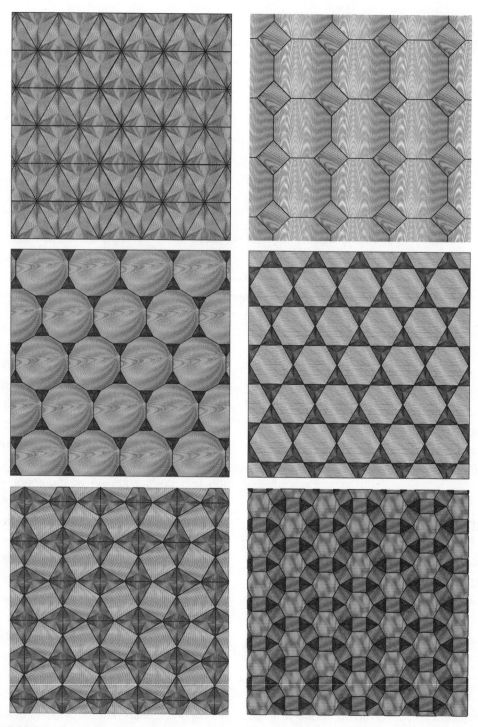

Figures 7.36–7.41 Selection of regular and semi-regular compositional grids with moiré (interference) effects (AH). Moiré effects adapted from Nicolai (2010).

8

three-dimensional lattices and other constructions

introduction

Most humans perceive the world as a three-dimensional entity consisting of length, breadth and depth. Some visual-arts practitioners must acknowledge all three dimensions even when using a representational two-dimensional surface (such as a sheet of paper, canvas or computer screen). The principal emphasis so far in this book has been on areas of immediate concern to visual artists representing or visualizing two-dimensional phenomena. The intention in this chapter is to identify and explain the nature of a small selection of three-dimensional phenomena. Useful introductions to the range of structural considerations of relevance to visual artists and designers working in three dimensions were provided by Wolchonok (1959), Wong (1977), Pearce (1990), Ching (1996) and Unwin (1997). More recently, an introduction to a selection of three-dimensional considerations in the visual arts was provided by the present author (Hann, 2012: 129–143).

The word 'lattice' can be used to refer to collections of points, spaced systematically, possibly connected by lines, in either two dimensions or three. A set of five two-dimensional lattice structures, known as Bravais lattices, are the structural basis for all possible types of regularly repeating plane patterns (Figures 8.1–8.5). Further explanation was given previously by the present author (Hann, 2012: 85–87). Occasionally the word 'net' is used to refer to lattice-type constructions, but in the context of this present book, it is reserved to refer to a flattened version of a three-dimensional object (as used with the flattened versions of the polyhedra dealt with in Chapter 3). Three-dimensional lattice structures have been employed by crystallographers as a means of modelling three-dimensional microscopic forms (see, for example, Hammond, 2009: 84–96) and these have been the inspiration for the representation of the lattice structures proposed here. Bravais proposed that a total of fourteen lattice types accommodated crystal structures in three-dimensional space, each consisting of combinations of certain symmetry operations (explained by Hammond, 2009: 88–90). At the macro level, Pearce (1978) considered lattices as a useful means of developing novel three-dimensional architectural structures. It is important to stress that lattice structures do not actually exist as collections of solid forms, but rather are models, each consisting of series of imaginary points associated with the vertices of a collection of imaginary unit cells.

Figures 8.1–8.5 The five Bravais lattices (CW).

For the sake of consistency with the more common scientific representations, the three-dimensional lattices introduced in this chapter are illustrated with small black spheres as external vertex points connected by straight lines to the neighbouring vertices. Each construction is visualized (and illustrated) as a transparent solid, with internal vertex points represented by white spheres and internal lines represented by dotted lines.

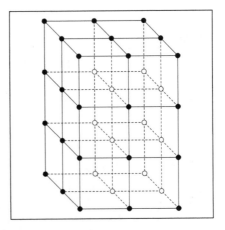

Figure 8.6 A cubic lattice (AH).

cubic and rectangular three-dimensional lattice constructions

When collections of cubes, or equivalent rectangular three-dimensional shapes, are placed face to face within a three-dimensional lattice structure, it is apparent that there will be six directions of communication at each internal vertex. That is, each vertex (where eight corners, one for each unit cell, meet at one point) will have six lines radiating from it, and each of these lines will denote where edges of unit cells meet (Figure 8.6).

Figures 8.7–8.12 present a series of rectangular three-dimensional lattice structures, based on the golden-section (1:1.618) rectangle, the root-2 (1:1.414) rectangle, the root-3 (1:1.732) rectangle, the root-4 (1:2) rectangle, the root-5 (1:2.236) rectangle and a plastic-number rectangle (1:1.3247), respectively. It is proposed here that these be employed as a basis for the development of three-dimensional compositional frameworks for use by visual artists and designers working in three dimensions.

domes

A three-dimensional form familiar to all architectural designers is the dome, a roof construction, often of hemispherical form, and conveniently described as a semi-circular arch rotated and extended around its vertical axis. Domes have a long architectural lineage and were used frequently by Roman engineers to cover wide spaces in temples and public buildings including the Pantheon. The principles of construction passed into Byzantine architectural traditions, manifested in the dome structure associated with Hagia Sophia in present-day Istanbul. Various remarkable domes were also constructed in Sasanian (224–651 CE) Persia, and, subsequently, domes became an important feature of Islamic architecture not only in Persia but across the Islamic world. Later they reached a peak of popularity during Safavid (early sixteenth to early eighteenth centuries), Ottoman (early sixteenth to late

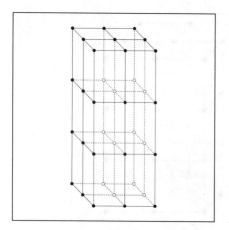

Figure 8.7 A golden-section-rectangle three-dimensional lattice (AH).

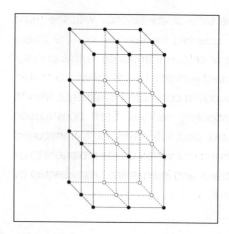

Figure 8.8 A 1:1.414 three-dimensional lattice (AH).

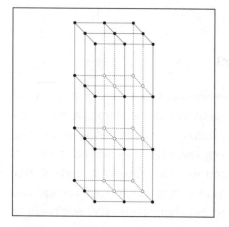

Figure 8.9 A 1:1.732 three-dimensional lattice (AH).

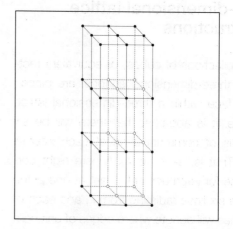

Figure 8.10 A 1:2 three-dimensional lattice (AH).

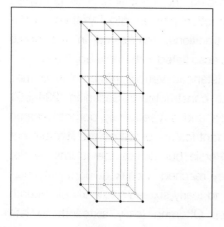

Figure 8.11 A 1:2.236 three-dimensional lattice (AH).

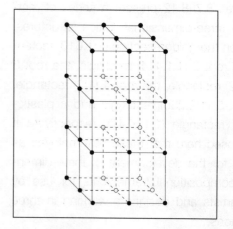

Figure 8.12 A 1:1.3247 three-dimensional lattice (CW).

seventeenth centuries) and Mogul (early six-teenth to early eighteenth centuries) times, in Persia, Turkey and India respectively. Domes retained popularity during Renaissance times across much of Europe; they became a feature of Russian Orthodox Christianity in particular, and were used commonly in the eighteenth-century Baroque period. Buildings with domes which appear to have played a substantial role in influencing subsequent architectural devel-opments include the Pantheon (Rome), Hagia Sophia (Istanbul), the Dome of the Rock (Jeru-salem), Saint Peter's Basilica (Vatican City), the Taj Mahal (Agra) and Saint Paul's Cathedral (London).

It is not known with certainty whether the use of the dome in building construction had a single origin historically or whether it was common simultaneously and independently to many cultures. Several types of historical dome structure can be identified. Examples include: the onion dome, which is bulbous and tapers to a point, and is associated commonly with Rus-sian Orthodox church architecture; the drum dome, which is probably the most widely used, is of hemispherical shape and is mounted on a cylindrical or drum-shaped base; the umbrella (or scalloped) dome, which is segmented by radial spokes or ribs from the central top of the dome to the base; the saucer dome, with a circular base, shallow and of low pitch, and resembling the shape of an inverted saucer; the sail dome (or sail vault, or handkerchief dome), which gives the impression of a square piece of cloth, pinned at the corners and bil-lowing upwards as if full of air. The construction known as a 'corbel dome' is among the most

ancient dome-like constructions and is created by placing each horizontal row of building units (e.g. approximately equally sized bricks or cut stones) further inwards compared to the previ-ous row until the final row meets at the top.

Geodesic domes are part-spherical and are based often on overlapping circular forms. In modern times, the term 'geodesic' has been associated with R. Buckminster Fuller, who designed a range of constructions following a series of experiments involving overlapping circles intersecting to form triangular sections on the surface of spheres. Examples of twenti-eth-century geodesic dome constructions, with various component polygonal shapes, include the Climatron (Missouri Botanical Garden), the America Pavilion for Expo 67 at the Montreal World's Fair and the Eden Project (Cornwall, UK). By the early twenty-first century, the use of innovative raw materials and design, manu-facturing and installation techniques permitted a wide variety of dome types. Newer forms of raw material included high-strength aluminium, galvanized steel and carbon fibre for frames, and lightweight toughened forms of glass, plas-tic (especially acrylics) and even copper, alu-minium and steel (coated with zinc) as panels or cladding.

space frames

In architectural and structural engineering, a space frame is a lightweight rigid construc-tion of triangular, square, hexagonal or other polygonal cells, used commonly in build-ing construction to span large areas without

interior support, or as frameworks associated with various aeronautical, nautical, automobile and motorcycle applications, as well as large lighting gantries, sporting and stage sets. Space frames are associated with Alexander Graham Bell, who, in the early twentieth century, sought rigid and lightweight structures for nautical and aeronautical engineering, and with Buckminster Fuller (in the mid-twentieth century), who sought suitable structures for architectural end uses. Space frames are common in late twentieth and early twenty-first-century buildings. Well-known examples include London's Stansted Airport (Foster Associates),

Hong Kong's Bank of China Tower (I. M. Pei and Partners) and Paris's Louvre Pyramid (I. M. Pei and Partners).

summary

This chapter introduced a range of three-dimensional lattice structures (based on well-known measures of proportion), and it was proposed that these could prove of value as three-dimensional compositional frameworks. Various types of dome were identified, and the nature of space frames was explained.

9

steps towards analysis

introduction

This chapter draws on observations made in previous chapters, and presents a simple straightforward approach to symmetry analysis in the visual arts and design. A small selection of case-study material is included.

past working methods

A frequent assumption is that ancient craftspeople held sophisticated mathematical knowledge and had access to, and understanding of, advanced geometrical texts. In reality, it is doubtful if this was the case, as it seems highly unlikely that the majority of ancient craftspeople possessed even basic literacy and numeracy skills. Geometrical knowledge held in ancient times, at least among artisans and craftspeople in Europe, was, it seems, founded on practical knowledge, passed probably from accomplished craftspeople to apprentices, and possibly also held in secret, as such knowledge was the foundation of employment and resultant income. So, it appears to be the case historically, at least until the Industrial Revolution of the eighteenth and nineteenth centuries in Europe, that practical knowledge of various crafts and building techniques, and of how to manipulate and shape raw materials of various kinds, was communicated orally from master to apprentice, father to son or, occasionally, mother to daughter. In some cases, this may have involved the use of certain basic geometrical instruments and associated constructions rather than reference to contemporary published mathematical principles or detailed plans. Importantly, documentary evidence of procedures is scant, and there are only a few advance drawings of intended final results. With this in mind, it should be understood that any analysis conducted in modern times on ancient artifacts or constructions cannot realistically reproduce or discover the procedures used in initial construction, although it should be recognized that occasionally a practical, hands-on approach, using tools believed to be contemporary with the construction being imitated, may help to build an awareness of possible working practices in ancient times. While knowledge of actual techniques and procedures may well have been lost with the passage of time or, at best, be open to conjecture, it is apparent that many constructions relied on certain underlying structural features (especially symmetry) to ensure their compositional integrity. It is the intention of this chapter to propose

a simple way of identifying underlying symmetry features; this in turn may allow for the development of our understanding of the nature of compositional decisions made by past visual artists and designers.

the potential of symmetry analysis

By the first decade of the twenty-first century, structural analysis in the visual arts and design had become a common research focus among mathematicians. The aim of structural analysis in the visual arts and design is largely to identify the underpinning geometry and, based on this, to develop an understanding of the working practices and creative actions of past visual artists and designers. Various avenues to facilitate analysis in the visual arts and design were outlined previously by the present author (Hann, 2012: 153–160), and it is not the intention to reproduce these here. Instead, a simple template which can be used readily by visual-arts-and-design students is proposed. This is based on assessing the symmetry characteristics displayed by photographic or other two-dimensional representations (e.g. of consumer products of various kinds, buildings or other constructions or monuments, as well as building façades, cross-section shapes and scaled floor plans). It is important to realize that symmetry is a fundamental aspect of underlying structure.

Symmetry classification, pioneered largely by the endeavours of scholars such as Washburn and Crowe (1988) in the later decades of the twentieth century, offers an objective, reproducible means for classifying regularly repeating patterns from different cultures and historical periods. By the middle of the second decade of the twenty-first century, symmetry classification and analysis of regularly repeating patterns has not been adopted widely among researchers; this may be because symmetry classification is regarded, at least by visual-arts-and-design students, as too complicated and requiring mathematical knowledge. For this reason, a simple symmetry template, aimed at facilitating the analysis of non-repeating designs, is suggested here.

A large proportion of compositions presented in square frameworks exhibit reflection symmetry (Hann, 2013: 33–34). Reflection may be in one direction only, or occasionally in two, three, four or more directions. Within a square-framed composition, one of three orders of reflection symmetry is common: one-direction reflection symmetry, two-direction reflection

Figure 9.1 Symmetry template (CW).

symmetry or four-direction reflection symmetry. A square with four axes (Figure 9.1) may be used as a convenient template or indicator of reflection symmetry in square compositions. A clear image (e.g. line drawing or photograph) deemed to be an accurate representation is selected for each object or construction to be analysed. A range of comments relating to selection of data sources, allowable margins of error and the necessity to ensure that data are representative were presented previously by the present author (Hann, 2012: 156, 159–160).

case studies

Figure 9.2 presents a series of six images, each consisting of the symmetry template superimposed on a floor plan. Figure 9.2a shows a plan of the Dome of the Rock (Jerusalem), Figure 9.2b the floor plan of Gyantse Kumbum (Tibet), Figure 9.2c the Bramante design for St Peter's Basilica (Vatican City), Figure 9.2d the plan of Shwezigon Paya (Myanmar), Figure 9.2e the plan of Pha That Luang (Lao) and Figure 9.2f the plan of Boudhanath Mahachaitya (Kathmandu). It is readily evident that all of the selected images display central organization and each fits conveniently within the square of the symmetry template. The floor plans of all six monuments display reflection symmetry in the direction of each axis of the template. It is reasonable to ignore minor deviations, and the actual rock located centrally in the Dome of the Rock (Figure 9.2a) can be considered as separate from the building itself. In each case, the design is based on a square (or a derivative construction such as an octagon or an eight-point star). It is worth remarking also that, in the design of each of the six floor plans, the use of a device similar to the template shown would have offered the designer a convenient reference for location of a centre point, and central and diagonal reflection lines.

Though the sample case studies were selected to show the applicability of the symmetry template, it was readily evident when making the selections that numerous alternatives were available. Plans based on regular polygons or circles are common, and often depict reflection symmetry in at least one direction. The use of this simple template could help therefore to identify the reflectional symmetry content and, subject to the availability of representative data sources, may give some further understanding of the compositional decisions made by the creator or designer of an image, object or building. So although the symmetry template is introduced here as a convenient and ready means to aid simple analysis, it should be remarked also that such a structure could be of assistance in the design process itself.

summary

Numerous scholars (many identified in previous chapters) have expressed the belief that visual compositions, designs and constructions of various types have been created and developed by conscious, or unconscious, reference to structural rules of one kind or another. Structural analysis holds the potential to identify time

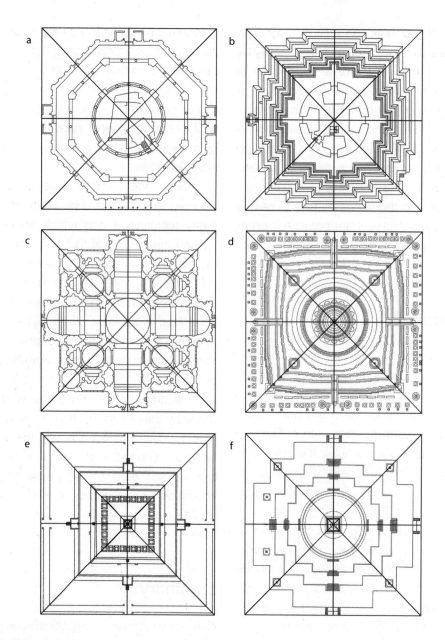

Figure 9.2 (a) Dome of the Rock (Jerusalem) (CW). (b) Plan of Gyantse Kumbum, Tibet (CW). (c) Bramante design for St Peter's (Vatican City) (CW). (d) Plan of Shwezigon Paya, Myanmar (CW). (e) Plan of Pha That Luang, Lao (CW). (f) Plan of Boudhanath Mahachaitya, Kathmandu (CW).

periods of cultural adherence and continuity, as well as change and adaptation. Symmetry analysis has been shown to be an objective and reproducible means for analysing and identifying underlying structure in the visual arts and design (see, for example, Washburn and Crowe, 1988). The purpose of this chapter is to present a simple square template of value to structural analysis; the use of such a template may prove an aid to the discovery of the compositional decisions that may have been made by past creators or designers. Further devices to aid analysis, such as a circular template to help with the identification of rotational symmetry, could also be devised, and the reader is invited to explore this further possibility.

transformation of compositional frameworks

introduction

The intention of this penultimate chapter is to illustrate the results of a procedure to transform grid structures into forms of potential value to practitioners. Various types of grid, based on well-known classes of tiling, were presented previously in Chapter 7, and it is believed that these could be of value as compositional grids to visual artists and designers. It was shown previously by the present author that the regular grids could be transformed to give various angled and curvilinear forms (Hann, 2012: 24–27). The purpose of this chapter is to recall the semi-regular and demi-regular forms of grid presented in Chapter 7 and, by way of example, to manipulate a selection of these to provide similarly transformed structures.

manipulation and transformation

Terzidis (2003: 57) observed that the term 'morphing' had been used to describe 'a process, in which an object changes its form gradually'. Meanwhile the term 'metamorphosis' describes a different process where change occurs in both form and also function (Terzidis, 2003: 57), though it should be noted that the term 'metamorphosis' has been used also in the context of M. C. Escher's tessellating designs, which incorporate a change in form of constituent elements from fish to birds for example. A process similar to morphing was proposed previously by the present author, when it was shown that various simple regular grid forms could be manipulated (or could undergo 'transformations') by using commonly available computer software (Hann, 2012: 24–31). A similar process is outlined here, but the focus is on selections from other grid classes. The term 'transformation' will continue to be used to refer to both the process and the outcome.

transformations of semi-regular, demi-regular and aperiodic grids

Examples of semi-regular grids, transformed by using commonly available software, are presented in Figures 10.1–10.3. Transformed examples from the demi-regular class of grids are

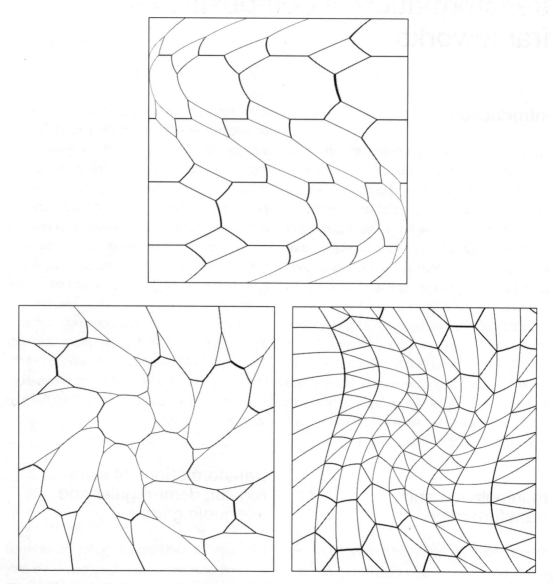

Figures 10.1–10.3 Transformations of semi-regular grids (CW).

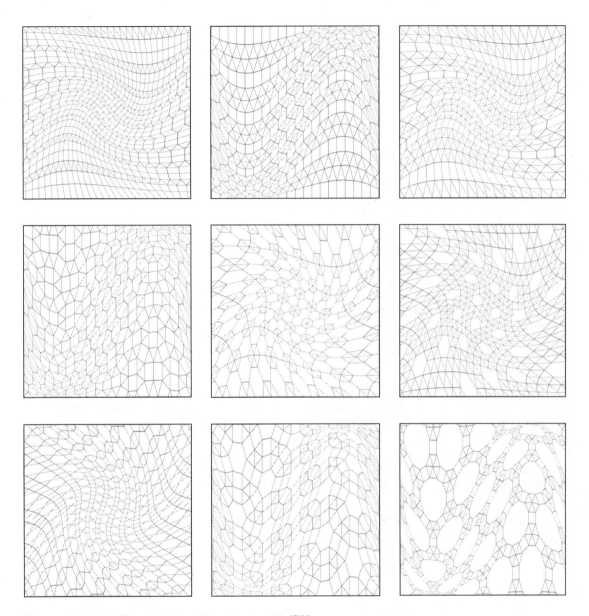

Figures 10.4–10.12 Transformations of demi-regular grids (CW).

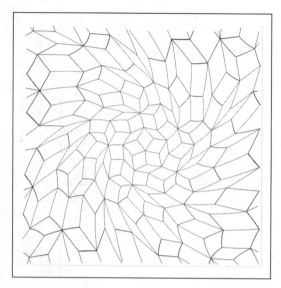

Figure 10.13 Transformation of an aperiodic grid (CW).

presented in Figures 10.4–10.12. A transformed version of an aperiodic tiling, of a type illustrated in Chapter 7, is presented in Figure 10.13.

summary

Two-dimensional grids of various kinds are used commonly by visual artists and designers, particularly as an aid in the precise placing of elements within a composition. It is believed that if grid forms of the types presented in this book are selected and used as compositional aids (e.g. in various forms of surface design), then the application of a system of transformation after compositional decisions have been made may lead to a range of visually innovative and interesting results.

11

in conclusion

Part of the concern of this book has been with various forms of simple design, known as stripes and checks, the former associated (conventionally) with assemblies of parallel linear components and the latter with two sets of such components intersecting at ninety degrees. A wide range of illustrative material has been included, highlighting the diversity possible within the confines or restrictions of each design type. A review was made of various systems of proportion, a concept deemed by a wide range of scholars, researchers and practitioners to be the foundation of harmonious composition in the visual arts and design.

Attention was turned to grids, and it appears that these have fulfilled an important role in the visual arts and design, both historically and in relatively modern times. Their usefulness in structural organization and in determining the placing of components of a composition was stressed. It was shown that grids may consist commonly of given-sized squares, equilateral triangles or regular hexagons, or may be based on special ratios or proportions. Various further categories of grid, based on well-known tiling classes, were introduced and manipulated (or transformed) using commonly available computer software. A series of three-dimensional lattices (based on various known systems of proportion) was introduced and their possible applicability to three-dimensional visual-art-and-design forms suggested.

The importance of symmetry in the visual arts and design was underlined. A simple template, aimed at assisting with the identification of the symmetry characteristics exhibited often within square compositions, was introduced and its application to visual analysis demonstrated. It was stressed that visual artists and designers should not fall into the trap of believing that one approach to proportional harmony is all-encompassing and applicable under all circumstances. Rather, it was stressed that visual artists and designers should develop an awareness of the wide range of concepts and principles associated with structure and form, including the various approaches to proportion, and, in particular, should retain such knowledge as part of a repertoire to draw on, and select from, when confronted with a particular assignment, brief or project. By way of a further illustrative example, two transformed compositional grids, from the same regular grid source, are presented in Figures 11.1 and 11.2.

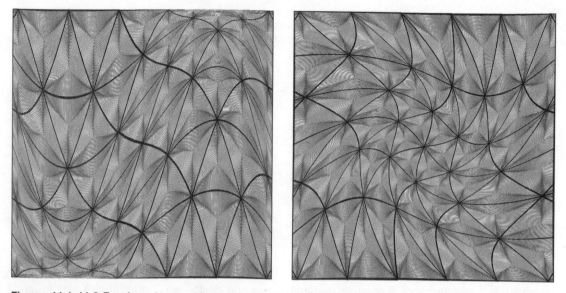

Figures 11.1–11.2 Transformed compositional grids (AH, with moiré effects adapted from Nicolai, 2010).

references

Adam, F. (1908). *The Clans, Septs and Regiments of the Scottish Highlands*, Edinburgh: W. and A. K. Johnston.

Ambrose, G. and Harris, P. (2008). *Basics. Design 07: Grids*, Lausanne: AVA Publishing.

Anon. (1957). 'Report of a Debate on the Motion that Systems of Proportion Make Good Design Easier and Bad Design More Difficult', *RIBA Journal*, 64: 456–63.

Arnheim, R. (1955). 'A Review of Proportion', *Journal of Aesthetics and Art Criticism*, 14 (1): 44–57.

Bain, R. (1938). *The Clans and Tartans of Scotland*, London: Collins.

Benjafield, J. (1985). 'A Review of Recent Research on the Golden Section', *Empirical Studies of the Arts*, 3 (2): 117–34.

Blake, E. M. (1921). 'Dynamic Symmetry – A Criticism', *The Art Bulletin*, 3 (3): 107–27.

Brunés, T. (1967). *The Secrets of Ancient Geometry*, 2 volumes, Copenhagen: Rhodos.

Byrne, P. (2014). Personal communication with the author, Belfast, June.

Campbell, A. (2000). 'Tartan and the Highland Dress,' in Way, G. and Squire, R. (eds) *Clans and Tartans*, Glasgow: Harper Collins, pp. 21–39.

Caskey, L. D. (1922a). 'Geometry of Greek Vases', *Museum of Fine Arts Bulletin*, 20 (117): 9.

Caskey, L. D. (1922b). *The Geometry of Greek Vases*, Boston, MA: The Museum of Fine Arts.

Ching, F. D. K. (1996). *Architecture, Form, Space and Order*, New York: John Wiley & Sons.

Cohen (2008). 'How Much Brunelleschi? A Late Medieval Proportional System in the Basilica of San Lorenzo in Florence', *Journal of the Society of Architectural Historians*, 67 (1): 18–57.

Collins Maps (2012). *Tartan Map of Scotland*, London: Collins Pictorial Maps.

Collins, P. (1962). 'The Origins of Graph Paper as an Influence on Architectural Design', *Journal of the Society of Architectural Historians*, 21 (4): 159–162.

Cook, T. A. (1914). *The Curves of Life*, London: Constable and Co., republished (1979), New York: Dover.

Cowan, P. (1979). *Rose Windows*, London: Thames and Hudson.

Davis, J. W. (1972). 'Unified Drawing through the Use of Hybrid Pictorial Elements and Grids', *Leonardo*, 5: 1–9.

Doczi, G. (1981). *The Power of Limits. Proportional Harmonies in Nature, Art and Architecture*, Boulder, CO: Shambhala Publications.

Dudley, C. J. (2010). *Canterbury Cathedral. Aspects of Its Sacramental Geometry*, Bloomington, IN: Xlibris.

Dunbar, J. T. (1962). *The History of Highland Dress*, Edinburgh: Oliver and Boyd.

Dunbar, J. T. (1984). *The Costume of Scotland*, London: Batsford.

Edwards, E. (1932 and 1967). *Dynamarhythmic Design*, New York: The Century Company, and in 1967 as *Pattern and Design with Dynamic Symmetry*, New York: Dover.

Einhäuser, W., Martin, K. A. and König, P. (2004). 'Are Switches in Perception of the Necker Cube Related to Eye Position?', *European Journal of Neuroscience*, 20 (10): 2811–2818.

Elam, K. (2001). *Geometry of Design: Studies in Proportion and Composition*, New York: Princeton Architectural Press.

Elam, K. (2004). *Grid Systems: Principles of Organizing Type (Design Briefs)*, New York: Princeton Architectural Press.

Erickson, B. (1986). 'Art and Geometry: Proportioning Devices in Pictorial Composition', *Leonardo*, 19 (3): 211–215.

Ernst, B. (1986). *Adventures with Impossible Figures*, Norfolk: Tarquin Publications.

Fechner, G. T. (1871). *Zur Experimentalen Aesthetik*, Leipzig: Hirzl.

Fischler, R. (1979). 'The Early Relationship of Le Corbusier to the Golden Number', *Environment and Planning*, 6: 95–103.

Fischler, R. (1981a). 'On the Application of the Golden Ratio in the Visual Arts', *Leonardo*, 14 (1): 31–32.

Fischler, R. (1981b). 'How to Find the "Golden Number" without Really Trying', *Fibonacci Quarterly*, 19: 406–410.

Fletcher, R. (2006). 'The Golden Section', *Nexus Network Journal*, 8 (1): 67–89.

Ghyka, M (1946). *The Geometry of Art and Life*, New York: Sheed and Ward, republication (1977), New York: Dover.

Gombrich, E. H. (1984). *The Sense of Order: A Study in the Psychology of Decorative Arts*, Ithaca, NY: Cornell University Press.

Graf, H. (1958). *Bibliographie zum Problem der Proportionen*, Speyer: Landesbibliothek.

Grant, J. (1886). *The Tartans and Clans of Scotland*, Edinburgh: W. and A. K. Johnston.

Green, C. D. (1995). 'All That Glitters: A Review of Psychological Research on the Aesthetics of the Golden Section', *Perception*, 24 (8): 937–968.

Grossman, E. and Boykin, M. A. (1988). 'Perceiving the Grid: Weaving the Tartan Plaid', *Art Education*, 41 (3): 14–17.

Hambidge, J. (1920). *Dynamic Symmetry. The Greek Vase*, New Haven, CT: Yale University Press.

Hambidge, J. (1926). *The Elements of Dynamic Symmetry*, London: Dover.

Hammond, C. (2009). *The Basics of Crystallography and Diffraction*, 3rd edn, Oxford: International Union of Crystallography and Oxford University Press.

Hampshire, M. and Stephenson, K. (2006a). *Communicating with Pattern: Circles and Dots*, Mies: Roto Vision SA.

Hampshire, M. and Stephenson, K. (2006b). *Communicating with Pattern: Stripes*, Mies: Roto Vision SA.

Hampshire, M. and Stephenson, K. (2007). *Squares, Checks and Grids*, Mies: Roto Vision SA.

Hann, M. (2012). *Structure and Form in Design*, London: Berg.

Hann, M. (2013). *Symbol, Pattern and Symmetry*, London: Bloomsbury.

Hargittai, I. (ed.) (1986). *Symmetry: Unifying Human Understanding*, New York: Pergamon.

Hargittai, I. (ed.) (1989). *Symmetry 2: Unifying Human Understanding*, New York: Pergamon.

Hemenway, P. (2005). *Divine Proportion Φ (Phi) in Art, Nature and Science*, New York: Sterling Publishing Co.

Hesketh, C. (1961). *Tartans*, London: Weidenfeld and Nicolson.

Huntley, H. E. (1970). *The Divine Proportion. A Study in Mathematical Beauty*, New York: Dover Publications.

Huylebrouck, D. (2009). 'Golden Section Atria', four-page manuscript provided courtesy of the author.

ICS (1906). *Weaves, Fabrics, Textile Designing*, in ICS Reference Library Series, Scranton, PA: International Textbook Company for International Correspondence School.

Innes (of Learney), T. (1945). *The Tartans of the Clans and Families of Scotland*, Edinburgh: W. & A. K. Johnston Ltd.

Iversen, E. (1960). 'A Canonical Master-Drawing in the British Museum', *Journal of Egyptian Archaeology*, 46: 71–79.

Iversen, E. (1968). 'Diodorus' Account of the Egyptian Canon', *Journal of Egyptian Archaeology*, 54: 215–218.

Iversen, E. (1976). 'The Proportions of the Face in Egyptian Art', *Studien zur Altägyptischen Kultur*, 4: 135–148.

James, J. (1973). 'Medieval Geometry. The Western Rose of Chartres Cathedral', *Architectural Association Quarterly*, 5 (2): 4–10.

James, J. (1978). *The Contractors of Chartres*, Dooralong: Mandorla.

Kappraff, J. (2000). 'A Secret of Ancient Geometry,' in Gorini, C. A. (ed.) *Geometry at Work*, MAA Notes Number 53, pp. 26–36.

Kappraff, J. (2002 and 2003 reprint), *Beyond Measure. A Guided Tour through Nature, Myth and Number*, River Edge, NJ: World Scientific.

Kelly, D. (1996). 'A Sense of Proportion: The Metrical and Design Characteristics of Some Columban High Crosses', *Journal of the Royal Society of Antiquaries of Ireland*, 126: 108– 146.

Lawlor, R. (1982). *Sacred Geometry: Philosophy and Practice*, London: Thames and Hudson.

Le Corbusier (1950a). *Le Modulor*. Boulogne sur Seine: Editions de l'architecture d'aujourd'hui; (1954 and 2nd edn. 1961), *The Modulor*, trans. P. de Francia and A. Bostock, London: Faber and Faber.

Le Corbusier (1950b). *Le Modulor 2*, Boulogne sur Seine: Editions de l'architecture d'aujourd'hui; (1958), *Modulor 2*, London: Faber and Faber.

Le Corbusier (2000). *The Modulor and Modulor 2*, 2 volumes, Basel: Birkhäuser.

Livio, M. (2002). *The Golden Ratio: The Story of Phi, The World's Most Astounding Number*, New York: Broadway Books.

Locher, P., Overbeeke, K. and Stappers, P. (2005). 'Spatial Balance in Color Triads in the Abstract Art of Piet Mondrian', *Perception*, 34 (2): 169–189.

Logan, J. (1831). *The Scottish Gaël*, London: Smith, Elder and Company.

Lorenzen, E. (1980). 'The Canonical Figure 19 and an Egyptian Drawing Board in the British Museum', *Studien zur Altägyptischen Kultur*, 8: 181–199.

MacInnes, A. (2000). 'A History of Clanship,' in Way, G. and Squire, R. (eds) *Clans and Tartans*, Glasgow: Harper Collins, pp. 5–20.

MacKay, E. (1917). 'Proportion Squares on Tomb Walls in the Theban Necropolis', *Journal of Egyptian Archaeology*, 4: 74–85.

MacKay, J. G. (1924). *The Romantic Story of the Highland Garb and Tartans*, Stirling: MacKay.

March, L. and Steadman, P. (1971). *The Geometry of Environment. An Introduction to Spatial Organization in Design*, London: RIBA Publications.

Markowsky, G. (1992). 'Misconceptions about the Golden Ratio', *College Mathematics Journal*, 23 (1): 2–19.

Martine, R. (2008). *Scottish Clan and Family Names: Their Arms, Origins and Tartans*, revised edn, Edinburgh: Mainstream Publishing.

McCague, H. (2003). 'A Mathematical Look at a Medieval Cathedral', *Math Horizons*, 10 (4): 11–15, 31.

McClintock, H. F. (1943). *Old Irish and Highland Dress*, Dundalk: W. Tempest.

McManus, I. C., Cheema, B. and Stoker, J. (1993). 'The Aesthetics of Composition: A Study of Mondrian', *Empirical Studies in the Arts*, 11 (2): 83–94.

Morgan, M. H. (1960 [1914]). *Vitruvius. The Ten Books of Architecture*, New York: Dover, previously Boston: Harvard University Press.

Neumann, E. M. (1996). 'Architectural Proportion in Britain, 1945–1957', *Architectural History*, 39: 197–221.

Nicolai, C. (2009). *Grid Index*, Berlin: Die Gestalten Verlag.

Nicolai, C. (2010). *Moiré Index*, Berlin: Die Gestalten Verlag.

O'Keeffe, L. (2013). *Stripes: Design between the Lines*, London: Thames and Hudson.

Olsen, S. (2006). *The Golden Section. Nature's Greatest Secret*, Glastonbury: Wooden Books.

Padovan, R. (1994). *Dom Hans van der Laan*. Amsterdam: Architectura and Natura Press.

Padovan, R. (1999). *Proportion. Science, Philosophy, Architecture*, London: Routledge.

Padovan, R. (2002). 'Dom Hans Van Der Laan and the Plastic Number,' in Williams, K. and Rodrigues, J. F. (eds) *Nexus IV: Architecture and Mathematics*, Fucecchio: Kim Williams Books, pp. 181–193.

Pearce, P. (1990). *Structure in Nature Is a Strategy for Design*, Cambridge, MA: MIT Press.

Pierce, J. C. (1951). 'The Fibonacci Series', *Scientific Monthly*, 73 (4): 224–228.

Prak, N. L. (1966). 'Medieval Architecture. Measurements at Amiens' *Journal of the Society of Architectural Historians*, 25: 2209–2212.

Proietti, T. (2012). 'The Tools of the Craft. Dom Hans van der Laan and the Plastic Number,' in Rossi,

M. (ed.) Nexus PhD Day, '*Relationships between Architecture and Mathematics*', *Proceedings of Nexus 2012*, Milano: McGraw-Hill, pp. 107–112.

Raghubir, P. and Greenleaf, E. A. (2006). 'Ratios in Proportion: What Should the Shape of the Package Be?', *Journal of Marketing*, 70 (2): 95–107.

Richter, G. M. A. (1922). 'Dynamic Symmetry from the Designer's Point of View', *American Journal of Archaeology*, 26 (1): 59–73.

Robins, G. (1985). 'Standing Figures in the Late Grid System of the 26th Dynasty', *Studien zur Altägyptischen Kultur*, 12: 101–116.

Robins, G. (1991). 'Composition and the Artists Squared Grid', *Journal of the American Research Center in Egypt*, 28: 41–54.

Robins, G. (1994a). 'On Supposed Connections between the "Canon of Proportions" and Metrology', *Journal of Egyptian Archaeology*, 80: 191–194.

Robins, G. (1994b). *Proportion and Style in Ancient Egyptian Art*, Austin, TX: University of Texas Press.

Russell, P. A. (2000). 'The Aesthetics of Rectangle Proportion: Effects of Judgment, Scale and Context', *American Journal of Psychology*, 113 (1): 27–42.

Samara, T. (2005). *Making and Breaking the Grid: A Layout Design Workshop*, Beverly, MA: Rockport Publishers.

Saxl, F. (1946). 'Lincoln Cathedral. The Eleventh Century Design for the West Front', *Archaeological Journal*, 103: 105–118.

Scarlett, J. D. (1972). *Tartans of Scotland*, London: Lutterworth Press.

Scarlett, J. D. (1973). *The Tartan Spotter's Guide*, London: Shepheard-Walwyn.

Scholfield, P. H. (1958). *The Theory of Proportion in Architecture*, Cambridge: Cambridge University Press.

Shelby, L. (1961). 'Medieval Masons' Tools I, The Level and the Plumb Rule', *Technology and Culture*, 2: 127–130.

Shelby, L. (1964). 'The Role of the Master Mason in Medieval English Building', *Speculum*, 39 (3): 387–403.

Shelby, L. (1965). 'Medieval Masons' Tools II, Compass and Square', *Technology and Culture*, 6: 236–248.

Shelby, L. (1970). 'The Education of Medieval English Master Masons', *Medieval Studies*, 32: 1–26.

Shelby, L. (1971). 'Medieval Masons' Templates', *Journal of the Society of Architectural Historians*, 30: 140–154.

Shelby, L. (1972). The Geometrical Knowledge of Medieval Master Masons', *Speculum*, 47: 395–421.

Shelby, L. (1977). *Gothic Design Techniques. The 15th Century Design Booklets of Mathes Roriczer and Hanns Schmuttermayer*, London: Pfeffer and Simons.

Shelby, L. (1979). 'Late Gothic Structural Design in the Instructions of Lorenz Lechler', *Architectura*, 9 (2): 113–131.

Smibert, T. (1850). *The Clans of the Highlands of Scotland*, Edinburgh: James Hogg.

Smith, H. S. and Stewart, H. M. (1984). 'The Gurob Shrine Papyrus', *Journal of Egyptian Archaeology*, 70: 54–64.

Smith, W. and Smith, A. (1850). *Authenticated Tartans of Scotland*, Mauchkine: W. and A. Smith.

Spinadel, V. W. de and Buitrago, R. (2008). 'Dynamic Geometric Constructions Based on the Golden Mean', *Slovak Journal of Geometry and Graphics*, 5 (10): 27–38.

Spinadel, V. W. de and Buitrago, R. (2009). 'Towards Van der Laan's Plastic Number in the Plane', *Journal of Geometry and Graphics*, 13 (2): 163–175.

Stewart, D. C. (1974). *The Setts of the Scottish Tartans*, London: Shepheard-Walwyn.

Stewart, D. W. (1893). *Old and Rare Scottish Tartans*, Edinburgh: George P. Johnston.

Stewart, M. (2009). *Patterns of Eternity. Sacred Geometry and the Starcut Diagram*, Edinburgh: Floris Books.

Stuart, J. S. and Stuart, C. E. (1845). *The Costume of the Clans*, Edinburgh: Menzies.

Teall, G. and Smith, P. (1992). *District Tartans*. London: Shepheard-Walwyn.

Terzidis, K. (2003). 'Hybrid Form', *Design Issues*, 19 (1): 57–61.

Thompson, D. W. (1917 and 1961). *On Growth and Form*, Cambridge: Cambridge University Press.

Trudeau, R. J. (1976). *Dots and Lines*, Kent, OH: Kent University Press.

Tubbs, M. C. and Daniels, P. N. (1991). *Textile Terms and Definitions*, 9th edn, Manchester: The Textile Institute.

Unwin, S. (1997). *Analyzing Architecture*, London: Routledge.

Urquhart, B. (2000). *Tartans. The Illustrated Identifier to Over 140 Designs*, London: Apple Press.

Urquhart, B. (2005). *Tartans of Scotland: An Alphabetical Guide to the History and Traditional Dress of Scotland*, London: Apple Press.

van der Laan, H. (1997). *Le Nombre Plastique: Quinze Leçons sur L'Ordonnance Arhitectonique*, Leiden: Brill Academic Pub.

Washburn, D. (ed.) (1983). *Structure and Cognition in Art*, Cambridge: Cambridge University Press.

Washburn, D. (ed.) (2004). *Embedded Symmetries, Natural and Cultural*, Albuquerque: University of New Mexico Press.

Washburn, D. K. and Crowe, D. W. (1988). *Symmetries of Culture: Theory and Practice of Plane*

Pattern Analysis, Seattle, WA: University of Washington Press.

Washburn, D. K. and Crowe, D. W. (eds) (2004). *Symmetry Comes of Age: The Role of Pattern in Culture*, Seattle, WA: University of Washington Press.

Way, G. and Squire, R. (eds) (2000). *Clans and Tartans*, Glasgow: Harper Collins.

Whitney, S. (2010). 'The Grid, Weaving, Body and Mind,' in *Textile Society of America Symposium Proceedings*, University of Nebraska, Lincoln, NE, Paper 60 (8 pp.).

Whyte, H. (1891). *The Scottish Clans and Their Tartans*, Edinburgh: W. and A. K. Johnston.

Whyte, H. (1906). *The Tartans of the Clans and Septs of Scotland*, Edinburgh: W and A. K. Johnston.

Williams, K. (1997). 'Michelangelo's Medici Chapel: The Cube, the Square and the Root-2 Rectangle', *Leonardo*, 30 (2): 105–112.

Williamson, J. H. (1986). 'The Grid: History, Use and Meaning', *Design Issues*, 3 (2): 15–30.

Wittkower, R. (1953). 'The Changing Concept of Proportion,' in *Architects' Year Book V*; in Wittkower, R. (1978) *Idea and Image*, London: Thames and Hudson, 109–123.

Wittkower, R. (1960). 'The Changing Concept of Proportion', *Daedalus*, 89 (1): 199–215.

Wittkower, R. (1978). *Idea and Image. Studies in the Italian Renaissance*, London: Thames and Hudson.

Wolchonok, L. (1959). *The Art of Three-dimensional Design*, New York: Dover.

Wong, W. (1977). *Principles of Three-Dimensional Design*, New York: Van Nostrand Reinhold.

Yoshimoto, K. (1993). *Textile Design III. Traditional Stripes and Lattices*, Singapore: Page One Publishing Company.

Zaczek, I. and Phillips, C. (2004). *The Illustrated Encyclopaedia of Tartan*, London: Lorenz Books (imprint of Anness Publishers Ltd).

Zaczek, I. and Phillips, C. (2009). *The Complete Book of Tartan: A Heritage Encyclopaedia of Over 400 Tartans and Stories That Shaped Scottish History*, London: Lorenz Books (with Anness Publishing).

Zeising, A. (1854). *Neue Lehre von den Proportionen des Menschlichen Körpers*, Leipzig: R. Weigel.

index

Locators followed by f denote figures.

Adam, F. 78
advertising, stripes in 10
Albers, Josef 43
Ambrose, G. 65, 68
Anon 60
aperiodic grids 109, 113f
 transformations of 130f
Archimedean polyhedra 48
argyle checks 78
arithmetical/geometrical
 proportion 54–5
Arnheim, R. 53
asymmetrical objects 8

Bain, R. 78
Benjafield, J. 57
Blake, E. M. 59
Boykin, M. A. 78
Bravais lattices 115, 116f
Breton stripes 9
Brunés Star 53, 61f
 proportion 60–2
Brunés, T. 60
Buitrago, R. 53
Burberry checks 75, 76, 81
Byrne, P. 64

C60 Buckminsterfullerene 50
Campbell, A. 78, 80–1
cartographic grid 66
cartoon 66
Caskey, L. D. 59
centralized form of organization 48, 49f
checks and tartans 5f, 73–81, 74f
 definition and classification 5f
 designs 82f–105f
 varieties 75–8
Cheema, B. 68
Ching, F. D. K. 45, 48, 53, 115
circles 42–3, 43f
classic stripes 9
clothing, stripes in 9
clustered organization 48, 49f
Collins, P. 67, 78
commensurable ratios 54f
commensurable systems 54
compositional grids 132f
consumer products, stripes in 10
Cook, T. A. 53, 57
Cowan, P. 56
Crowe, D. W. 41, 122, 125

cube 48, 50f, 51f
 Necker 44, 46f
 net 51f
cubic lattice 117, 117f

Daniels, P. N. 76, 80
da Vinci, Leonardo 48
Davis, J. W. 66, 68
decagon, regular 45
De Divina Proportione (Pacioli) 48, 57
demi-regular grids 107, 110f
 transformations of 129f
designed object 7
designs. See also specific types
 circular form of 42
 stripes 14, 16f–39f
division of space, grids 107–14
 aperiodic 109, 113f
 demi-regular 107, 110f
 non-edge-to-edge 107–8, 112f
 regular grids 107, 108f, 114f
 semi-regular 107, 109f, 114f
Doczi, G. 57
dodecahedron 48, 50f, 52f
 net 52f
domes 117–19
Dudley, C. J. 56
Dunbar, J. T. 78
Dürer, Albrecht 43
dynamic symmetry 53, 58–60

Edwards, E. 59
Egyptian triangle 45, 46f
Einhäuser, W. 44
Elam, K. 45, 57, 65, 68
enneagon, regular 45
equilateral triangle 45
Erickson, B. 56
Ernst, B. 45
Escher, M. C. 45

Fechner, G. T. 57
Fibonacci series 58
Fischler, R. 57
Fletcher, R. 57
4 × 4 magic square 43, 44f
Fuller, R. Buckminster 50

geodesic domes 50, 119
geometrical knowledge 121
geometric proportion 54–5

gingham 76
 checks 75
golden section 55, 57–8
 proportion 57–8
 rectangle 58f
 spiral 58f
Gombrich, E. H. 45, 53
Graf, H. 53
Grant, J. 78
graph 67
Green, C. D. 57
Greenleaf, E. A. 57
grids 65–71
 aperiodic 109, 113f
 cartographic 66
 compositional role of 67
 definitions and types 65–6
 demi-regular 107, 110f
 division of space (see division of
 space, grids)
 form of organization 48, 49f
 in modern European visual art 67
 range of applications 66–8
 from rectangles 68–71
 surface-pattern designers 68
 three-by-three 65f
Grossman, E. 78
group of rectangles 53

halo 42–3
Hambidge, J. 53, 58–9
Hammond, C. 115
Hampshire, M. 9–10, 43, 75–80
hand-cut katagami 11, 12f
Hann, M. 1, 3, 7–8, 8, 16, 41–3, 45, 48,
 50, 58, 60, 62–3, 107–9, 115,
 122–3, 127
Hargittai, I. 41
Harris, P. 65, 68
Hemenway, P. 57
heptagon, regular 45
Hermann grid 44, 44f
Hesketh, C. 78
hexagon, regular 45
hound's tooth checks 75
Huntley, H. E. 57
Huylebrouck, D. 57

icosahedron 48, 50f, 52f
 net 52f
 truncated 48, 52f

ICS 11
'impossible' polygons 45, 47f
impossible triangle 45, 47f
incommensurable systems 54
Innes, T. 78
interior design, stripes in 9, 11
irregular stripes 11, 13
isosceles triangle. *See* thirty-six-degrees
 isosceles triangle
Italian Renaissance 43
Iversen, E. 55

Japanese striped textiles 11

Kappraff, J. 43, 61–2
katagami 11, 12f, 76, 77f
Kelly, D. 56
knitted leg coverings 14f
König, P. 44

lattice 115
Lawlor, R. 43, 57
limits, lines defining 8
linear organization 48, 49f
lines
 defining limits 8
 description 7–8
 examples of usage 7–8
 length of 7, 8f
 as markers 7
 as 'polyhedra' 41
Livio, M. 57, 60
Locher, P. 68
Logan, J. 78
Lorenzen, E. 55

MacInnes, A. 78, 80
MacKay, E. 55
MacKay, J. G. 78
magic square 43
 4 × 4 43, 44f
 3 × 3 43, 44f
March, L. 53–4
markers, lines as 7
Markowsky, G. 57
Martine, R. 78
Martin, K. A. 44
mathematical knowledge 121
McCague, H. 57
McClintock, H. F. 78
McManus, I. C. 68
Melancholia I 43
Modulor proportion 60
Modulor, The (1954) 60
Morgan, M. H. 56
Mysterium Cosmographicum 57

Necker cube 44, 46f
nets, polyhedra 48, 51f–52f
Neumann, E. M. 53, 60
Nicolai, C. 68, 114, 132
non-edge-to-edge grids 107–8,
 112f

objects
 asymmetrical 8
 designed 7
 symmetrical 8
observable bias 45, 48
octagon, regular 45
octahedron 48, 50f, 51f
octahedron net 51f
O'Keeffe, L. 11
Olsen, S. 57
optical effects
 and square 44
 and stripes 9
outer spatial boundaries 8. *See also*
 outlines
outlines 8, 61, 66
Overbeeke, K. 68

Pacioli, Luca 48
Padovan, R. 53, 55, 62–3
Pearce, P. 115
Penrose, Roger 45
 triangle (*see* impossible triangle)
pentagon, regular 45
Phillips, C. 78
Pierce, J. C. 57
pinstripes 9
pivot points 79
plastic number 53
 proportion 62–3
Platonic polyhedra 48, 50f
Pollio, Marcus Vitruvius 56
polygons 7
 'impossible' 45, 47f
 regular 45
polyhedra
 Archimedean 48
 lines as 41
 nets 48, 51f–52f
 Platonic 48, 50f
 and spheres 48, 50
Prak, N. L. 56
Proietti, T. 62–3
promotion, stripes in 10
proportion 53–64
 arithmetical/geometrical 54–5
 Brunés Star 60–2
 dynamic symmetry 58–60
 evidence for past use 55–7
 golden section 57–8
 Modulor 60
 plastic number 62–3
 structural 53
 systems of 53
 Williams's study of 56
*Proportion and Style in Ancient
 Egyptian Art* (1994b) 56

radial organization 48, 49f
Raghubir, P. 57
rectangles
 grids from 68–71
 of whirling squares 59f

reflection symmetry 41, 42f, 50
Regency stripes 9
regular decagon 45
regular enneagon 45
regular grids 107, 108f, 114f
regular heptagon 45
regular hexagon 45
regular octagon 45
regular pentagon 45
regular polygons 45
regular stripes 11, 13–14
Richter, G. M. A. 59
right-angled triangle 45, 46f
Riley, Bridget 9
Robins, G. 55–6
root rectangles 53
rosettes 42
rotational symmetry 41, 42f, 50
Russell, P. A. 57

sacred-cut square 43, 44f
Samara, T. 66, 68
Saxl, F. 56
Scarlett, J. D. 78
Scholfield, P. H. 53–4
Scottish clan tartans 78–81
sectio aurea. See golden section
semi-regular grids 107, 109f, 114f
 transformation of 127, 128f
Shelby, L. 56
shepherd's checks 75
shirting stripes 9
simple template 131
Smibert, T. 78
Smith, A. 78
Smith, H. S. 55
Smith, P. 78
Smith, W. 78
space frames 119–20
spatial organization 45, 48
spheres, description 50
Spinadel, V. W. de 53
square
 description 43–4
 magic 43
 and optical effects 44
 in puzzles and games 43
 sacred-cut 43, 44f
 usefulness of 43
Squire, R. 78
Stappers, P. 68
Steadman, P. 53–4
Stephenson, K. 9–10, 43, 75–80
Stewart, D. C. 14, 78–81
Stewart, D. W. 78, 81
Stewart, H. M. 55
Stewart, M. 62
Stoker, J. 68
striped T-shirts 9
stripes. *See also specific types*
 in advertising and promotion 10
 Breton 9
 classic 9

classification of 8–14
in clothing 9
and colours 13–14
in communication of themes/moods
 10
conventional 3f–4f
designs 14, 16f–39f
as directional devices 9
indicating membership of gathering/
 group 9
in interior design 9, 11
irregular 11, 13
in Japanese textiles 11
and optical effects 9, 10
Regency 9
regular 11, 13–14
shirting 9
textile 9, 10f, 11, 13
tiger 8, 9, 11
and visual illusion 9
zebra 8, 13
Stripes: Design between the Lines
 (O'Keefe) 11
structural proportion 53
Stuart, C. E. 78
Stuart, J. S. S 78
successive root rectangles 59f
surface-pattern designers 68
symmetrical objects 8
symmetry
 analysis 122–3
 Bramante design for St Peter's (Vati-
 can City) 124f
 case studies 123, 124f
 Dome of the Rock (Jerusalem) 124f
 plan of Boudhanath Mahachaitya,
 Kathmandu 124f
 plan of Gyantse Kumbum, Tibet 124f
 plan of Pha That Luang, Lao 124f

plan of Shwezigon Paya,
 Myanmar 124f
template 122f, 123
systems of proportion 53

Tartan Map of Scotland 78
tartans 73–81
 colours in 80
 Scottish clan 78–81
 varieties 81
tattersall checks 75
Teall, G. 78
Terzidis, K. 127
tetrahedron 48, 50f, 51f
tetrahedron net 51f
textile-related publications 11
textile stripes 9, 10f, 11, 13
T.G. Green 9
Theban tombs 55
thirty-six-degrees isosceles triangle
 45, 46f
Thompson, D. W. 53, 57
Thread (numbers) 80
 Black Watch tartan 80
 Campbell of Breadalbane tartan 80
 Gordon (tartan) 80
 MacGowan (tartan) 80
 MacPherson (tartan) 80
 Royal Stuart (tartan) 80
 warp-ways 75
 weft-ways 75
3 × 3 magic square 43, 44f
three-by-three grid 65f
three-dimensional lattices 115–20, 118f
ticking 9
tiger stripes 8, 9, 11
transformations 127–30
triangle
 description 44–5

Egyptian 45, 46f
equilateral 45
impossible 45, 47f
right-angled 45, 46f
thirty-six-degrees isosceles 45, 46f
Trudeau, R. J. 68
truncated icosahedron 48, 52f
Tubbs, M. C. 76, 80
two-dimensional figures 7, 8

University of Leeds 2, 11, 14
Unwin, S. 115
Urquhart, B. 78–80

van der Laan, H. 53, 62
vesica piscis 43, 43f
visual illusion, and stripes 9
visual organization. *See* spatial
 organization

warp-ways direction 9
Washburn, D. 41, 122, 125
Way, G. 78
weft-ways direction 9
western plaid checks 75
Whitney, S. 73
Whyte, H. 78
Williams, K. 56
 study of proportion 56
Williamson, J. H. 66
Wittkower, R. 53–5
Wolchonok, L. 115
Wong, W. 115

Yoshimoto, K. 11

Zaczek, I. 78
zebra stripes 8, 13
Zeising, A. 57